W9-AED-210

Georgia O'Keeffe *Nature and Abstraction*

Georgia O'Keeffe
Nature and Abstraction

Richard D. Marshall

with texts by
Yvonne Scott and Achille Bonito Oliva

SKIRA

Editor
Seán Kissane

Design
Marcello Francone

Editorial Coordination
Marzia Branca

Editing
Doriana Comerlati

Layout
Lorena Biffi

Translation
Alice Chambers
Paul Metcalfe for *Scriptum*,
Rome

First published in Italy in 2007 by
Skira Editore S.p.A.,
Palazzo Casati Stampa
via Torino 61
20123 Milano
Italy
www.skira.net
Irish Museum of Modern Art,
Dublin
Vancouver Art Gallery,
Vancouver

Printed and bound in Italy.
First edition

Soft cover
ISBN-13: 978-88-6130-128-3
ISBN-10: 88-6130-128-2

Hard cover
ISBN-13: 978-88-6130-127-6
ISBN-10: 88-6130-127-4

Distributed in North America by
Rizzoli International
Publications, Inc., 300 Park
Avenue South, New York,
NY 10010.
Distributed elsewhere in the
world by Thames and Hudson
Ltd., 181a High Holborn,
London WC1V 7QX, United
Kingdom.

Georgia O'Keeffe
Nature and Abstraction

Irish Museum of Modern Art, Dublin
7 March – 13 May 2007

Vancouver Art Gallery, Vancouver
5 October 2007 – 13 January 2008

Exhibition curated
by Richard D. Marshall

Georgia O'Keeffe *Nature
and Abstraction* is organized
by the Irish Museum
of Modern Art in collaboration
with the Vancouver Art Gallery

IMMA Exhibition Team
Enrique Juncosa,
Director
Rachael Thomas,
Senior Curator
Head of Exhibitions
Seán Kissane,
Curator Exhibitions
Nicola Lees,
Assistant Curator
New Galleries
Cillian Hayes,
Head of Technical Crew
Chris Fite-Wassilak
Exhibitions Assistant

Imma Patrons
Abhann Productions
Bank of Ireland
DIAGEO
Ivor Fitzpatrick
Maurice and Maire Foley
George and Maura McClelland
Eoin and Patricia McGonigal
Mary J. O'Driscoll-Levy
Lochlann Quinn
Brian and Elsa Ranalow
Noel Smyth
Patricia Tsouros and John
Leech

Imma Benefactors
Adam's
Eileen and Paul Bowman
Brennan Insurances
Jackie and Campbell Bruce
Abdul Bulbulia
Philip Carton
Suzanne MacDougald
Loretto Meagher
Anraí Ó'Braonáin
James O'Driscoll
Cormac O'Malley
Gearóid Ó Súilleabháin
Michael O'Sullivan
Maureen Porteous
Anonymous

Irish Museum of Modern Art
Áras Nua-Ealaíne Na hÉireann
Royal Hospital, Military Road,
Kilmainham, Dublin 8, Ireland

info@imma.ie
www.imma.ie

The exhibition in Dublin is
presented in association with

THE IRISH TIMES

Vancouver Artgallery

Vancouver Art Gallery
750 Hornby Street
Vancouver, BC
V6Z 2H7
604.662.4700

Contents

Foreword

We are pleased to present for the first time in Ireland, and only the second time in Canada, a solo exhibition of the work of an artist who is central to an understanding of the origins of Modernism in the United States. Georgia O'Keeffe was born in Sun Prairie, Wisconsin, in 1887, and in 1905 enrolled in the Art Institute of Chicago. In 1907, O'Keeffe went to study at the Arts Student League in New York, where she regularly visited the now-mythical Gallery 291, which allowed her to become familiar with the work of European avant-garde artists such as Auguste Rodin, Paul Cézanne and Henri Matisse. The 291 was run by Alfred Stieglitz, editor of the influential magazine Camera Work, *who, after seeing some of her charcoal drawings, included O'Keeffe in several group shows and began an intense relationship that would last thirty years. Stieglitz was twenty-three years her senior, but they shared an interest in a range of subjects, from Japanese art and mysticism, to Buddhism, alchemy and Carl Jung. O'Keeffe and Stieglitz eventually married in 1924.*

During this period, O'Keeffe came into contact with artists such as Marcel Duchamp and Francis Picabia, and began a series of exhibitions with a group of artists that Stieglitz termed the Seven Americans, including—alongside O'Keeffe and himself—Charles Demuth, Paul Strand, John Marin, Marsden Hartley, and Arthur G. Dove. Her work was quick to gain wide recognition, and in 1943 she was given a one-woman retrospective at the Art Institute of Chicago. Following this, in 1946, O'Keeffe was the first woman to have a retrospective at the Museum of Modern Art in New York.

Georgia O'Keeffe's early works present close-ups of flowers and fruits, painted without any surrounding contexts, generating an almost abstract space. It was this work with which she was most identified, and a large number of critics evoked Freudian notions to find sexual meaning in her painting. In 1925, after the couple moved to the 28th floor of the Sheraton Hotel, O'Keeffe started painting the skyscrapers of New York, beginning her engagement with architecture that would last into the late 1930s. She began, however, to feel the confinement of the city and longed to return to the spaces of the West, such as Texas, where she had taught from

1916. When she visited a friend in Taos, New Mexico, in 1929, she fell immediately in love with the vast landscape, which inspired strange and beautiful images incorporating crosses, skulls and the land itself. She would return to New Mexico every summer she could following that, and eventually after the death of Stieglitz in 1946, she settled there, continuing to paint this landscape until her death in 1986.

O'Keeffe's work is most often based in nature, featuring flowers, leaves, fruits, shells or skulls set amongst different landscapes. These images go from clear representation to purely abstract shapes, with colours that tend to be more conceptual than naturalistic, adding to a permanent sensation of clarity. She manages to imbue all of her subjects with a restrained eroticism and mysticism. Some of her images may suggest the romantic tradition of the sublime, but they also maintain a particular earthiness. The group of works gathered together in this exhibition by Richard Marshall, a former curator at the Whitney Museum in New York, centre around the natural origin of Georgia O'Keeffe's abstractions. We would like to thank him for his scholarly dedication to this project, and for his clear and well informed text. We also extend our thanks to the other contributors to the book, Dr. Yvonne Scott and Prof. Achille Bonito Oliva. Many individuals have helped in the organization of this exhibition and the publication of this book. At IMMA our thanks go to the staff who organized the exhibition and catalogue: Rachael Thomas, Seán Kissane, Nicola Lees and Chris Fite-Wassilak. We would also like to thank the entire exhibition team of Vancouver Art Gallery for their extraordinary labours. Thanks are also due to Francesco Baragiola at Skira Editore, Milan, for the time and energy he and his team have dedicated to this publication. We would like to thank Bill Katz for his advice and support. Finally, an exhibition of this nature is impossible without the goodwill and generosity of the lenders and we would like to thank all of them for their significant support of this exhibition.

Enrique Juncosa
Director, Irish Museum of Modern Art

Kathleen S. Bartels
Director, Vancouver Art Gallery

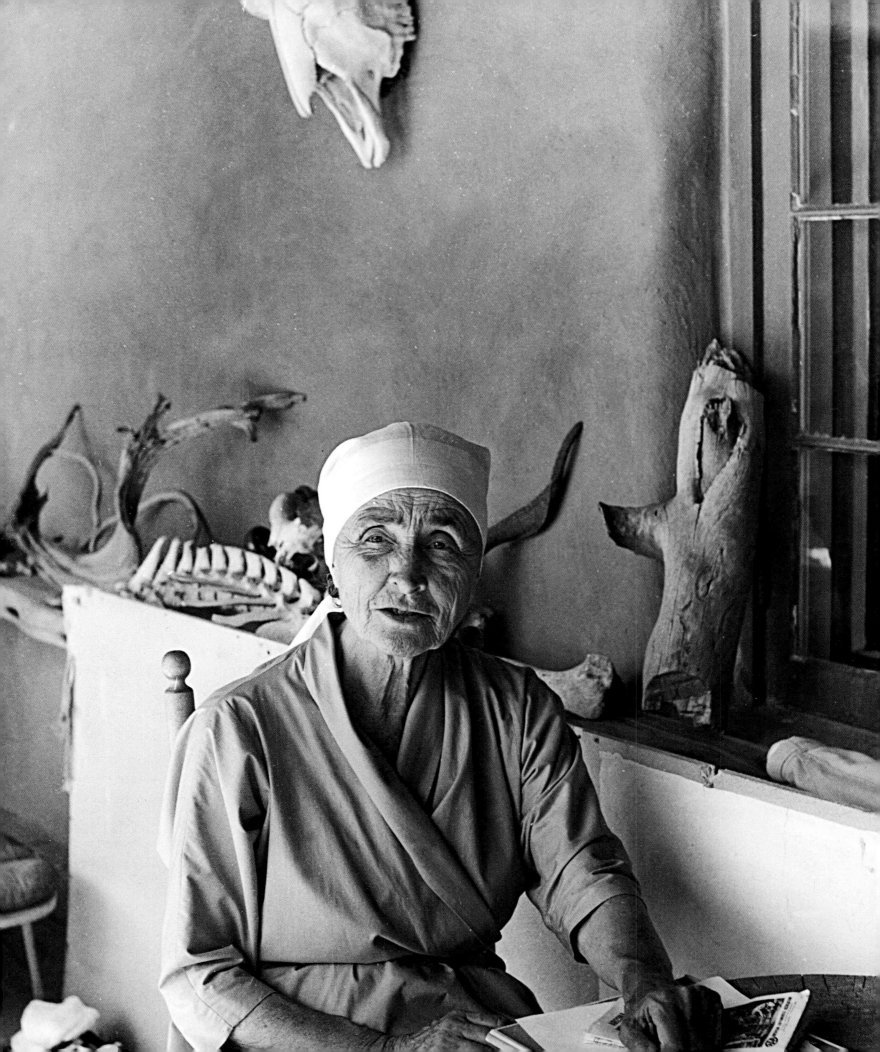

Richard D. Marshall

Georgia O'Keeffe: Nature and Abstraction

Todd Webb, Georgia O'Keeffe on the Portal, Ghost Ranch, New Mexico, 1964

"Abstraction is often the most definite form for the intangible thing in myself that I can clarify in paint... I found I could say things with color and shapes that I couldn't say any other way—things I had no words for."[1]

The artistic career of Georgia O'Keeffe (1887–1986) spans almost the entirety of the twentieth century. Her earliest works were done in 1915 and she continued to paint until failing eyesight forced her to stop in the mid 1970s. During her long career, O'Keeffe established herself as a major figure in American art, first as a member of the "Alfred Stieglitz Circle" of modern artists in New York including Arthur Dove, Marsden Hartley, and John Marin. She continued to thrive as an independent and confident artist who remained constant to her unique aesthetic. Her vision—based on finding the essential, abstract forms in the subjects she painted—evolved during the first twenty years of her career and continued to inform her later work. Since her death in 1986, her importance, eminence, and influence have continued to grow stronger, establishing her as an artist of international significance.

Georgia O'Keeffe: Nature and Abstraction focuses on her consistent determination to transform known or recognizable things into painted, abstract entities that express their essence through forms, colors, and allusions. It also presents a unique opportunity to survey her entire career and to review the majority of the subjects that interested her by concentrating on the most dominant aspect of her achievement and the one that constantly inspired her—transforming nature into abstraction.

Although O'Keeffe is best known in the United States, her work aligns with that of the major figures of twentieth-century Modernism, both European and American. Artists as diverse as Claude Monet, Piet Mondrian, Pablo Picasso, Willem de Kooning, and Ellsworth Kelly share with O'Keeffe the observation of nature as the inspiration for their subject matter. Her subjects were taken from life, and related both generally and specifically to places where she visited and lived. Through her art she explored the subtle nuances of a setting or the form and color of a physical object or locale.

O'Keeffe's art changed dramatically when she moved to New York in 1918. She began to work almost exclusively with oil paint on generally larger canvases, and gave up her previous use of watercolor on paper. As early as 1915, O'Keeffe realized that her previous art training was useless: "I had been taught to work like others and after careful thinking I decided that I wasn't going to spend my life doing what had already been done... I decided to start anew—to strip away what I had been taught—to accept as true my own thinking."[2]

More importantly, she shifted her attention to almost totally abstract compositions. Her first major

[1] O'Keeffe statement in "Alfred Stieglitz Presents One Hundred Pictures: Oils, Watercolors, Pastels, Drawings by Georgia O'Keeffe, American" (1923), in Barbara Buhler Lynes, *Georgia O'Keeffe: Catalogue Raisonné* (New Haven: Yale University Press; National Gallery of Art, Washington, DC; Georgia O'Keeffe Foundation, Abiquiu, New Mexico, 1999), vol. 2, p. 1098.
[2] *Georgia O'Keeffe* (New York: Viking Press, 1976; reprinted, New York: Penguin Books, 1985), n.p.

pictures of 1918–19 were highly abstracted images, painted in strong colors—red, blue, green, orange—that were often inspired by music, such as *Series I, No. 4* (1918). A related work, *Series I, No. 8* (1919), although completely abstract, presents vaguely familiar curvilinear and oval shapes. Red tubular forms rise from the bottom of the canvas and sweep the eye upwards, around the circling blue, and toward the exact center of the canvas. Monet used a similar technique in his paintings, such as *Water Lilies (Nympheas)*, 1907. The painting is dominated by an inverted V-shape that emerges from the bottom of the canvas and points toward the top center. Monet has created this abstract shape by manipulating his observations of the reflection in the water of sky and trees. The subject matter of water lilies seems of secondary interest to Monet.

O'Keeffe's next group of paintings was generated by annual trips to the Alfred Stieglitz family country estate in Lake George, New York. O'Keeffe noted that: "There is something so perfect about the mountains and the lake and the trees—sometimes I want to tear it all to pieces—it seems so perfect."[3] She achieved this on canvas by transforming the tranquil lake and calm sky into masses of swirling and arching shapes suggesting hostile waters and thundering, threatening skies. *Untitled (Abstraction)*, 1918, suggests a dark, smoke filled sky above billowy, orange flames. Similarly *Abstraction* (1921), *Mountains to North – Autumn – Lake George, N.Y.* (1922), and *Dark Abstraction* (1924) are dark, brooding paintings that allude to night skies, light reflections, or fractured landscapes.

Brighter, more colorful works such as *Spring* (1922) and *Birch Trees* (1925), were also painted at Lake George and make a slightly more direct reference to nature. The birch trees were painted at dawn and the undulating, cylindrical tree trunks reflect a bright morning light. O'Keeffe has chosen to represent the trees as flat curving lines with only a minimal attention to green foliage. *Spring* also depicts an abstract landscape of rebirth and life, trees and sky, and expanding forms in a Cubist inspired composition. In these works, O'Keeffe is transforming the essence of a tree in a manner similar to Picasso's early Cubist *Landscape* (1908) and Mondrian's geometric *Trees* (c. 1912).

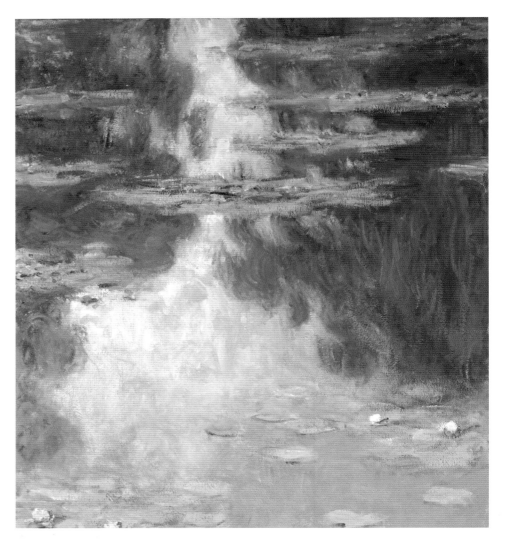

In the early 1920s, O'Keeffe also began to investigate the potential for abstraction using a single flower to fill the entire canvas. She realized that her contemporaries might not be impressed with her new subject matter: "I'm going to paint it big so they will have to look at it… they looked because they were big… it just amused me, the idea of getting them to see what I saw."[4] The blossoms themselves fascinated her—not foliage or plants in their natural setting. *Flower Abstraction* (1924) is one of a major, early series of flower paintings. The flower form fills the canvas, and its petals open to reveal its lighter inner core. Brilliant expanses of orange and pink create strong, warm shapes from which small details emerge in powerful three-dimensionality. The painting reveals the extension of her investigation of abstraction by eliminating any suggestion of actual petals, and presenting only soft, rolling and folding shapes in shades that merely allude to their source. Later flowers, such as *Purple*

Claude Monet, *Water Lilies (Nymphéas)*, 1907
Oil on canvas
36 1/4 × 31 15/16 inches
(92.1 × 81.2 cm)
The Museum of Fine Arts, Houston. Gift of Mrs. Harry C. Hanszen

[3] O'Keeffe letter to Sherwood Anderson (1923) in Jack Cowart, Juan Hamilton, and Sarah Greenough, *Georgia O'Keeffe: Art and Letters* (National Gallery of Art, Washington, DC; Boston: New York Graphic Society Books, 1987), p. 173.
[4] O'Keeffe statement in Perry Miller Adato, *Georgia O'Keeffe*, videotape. (WNET/THIRTEEN for Women In Art, 1977.)

Pablo Picasso, *Landscape*, 1908
Oil on canvas
39 5/8 × 32 inches
(100.8 × 81.3 cm)
Museum of Modern Art
(MoMA), New York.
Gift of Mr. and Mrs.
David Rockefeller.
Acc. no.: 1413.1974

Petunias (1925) and *White Flower* (1932), continue O'Keeffe's fascination with floral imagery. These works focus the viewer's eye directly into the center of the flower's reproductive pistil and stamen, surrounded and framed by enlarged purple or white petals, in a manner not dissimilar to Mondrian's 1907 treatment of *Red Amaryllis with Blue Background.* At a later date Andy Warhol completed a series of screen-printed flowers, such as *Ten-Foot Flowers* (1967), that also concentrated on the center of the flower, perhaps not as reproductive parts, but because in his paintings they resemble an anus.

In *Yellow Leaves* (1928) and *Oak Leaves, Pink and Grey* (1929) the artist examines every crevice, vein, and serrated edge of the leaves, exploring the beauty of autumnal decay in nature. In both paintings, O'Keeffe has created compositions that are both objective, because the leaves are recognizable subjects, and abstract, because the broad expanse of color and movement compels the viewer to read images in terms of pure form and color. As O'Keeffe's titles suggest, equal importance is given to the subject and the color. Each painting contains two overlapping leaves, and the artist's main interest is the variable shades of yellows, pinks, and greys that are contained by the shape of the leaf and the boundaries of the canvas. As O'Keeffe noted: "Color is one of the great things in the world that makes life worth living to me, and as I have come to think of painting it is my effort to create an equivalent with paint color for the world—life as I see it."[5]

Two of O'Keeffe's most lyrical and abstract compositions are related in concept and structure, but differ in form and palette. *Abstraction* (1926) presents numerous overlapping forms, as seen previously in *Abstraction* (1921), *Flower Abstraction* (1924), and *Birch Trees* (1925). But here, her forms are flat and planar, like folded paper or sheets, and painted in soft, muted color. A strong vertical thrust suggested in earlier paintings is forcefully delineated in *Abstraction* by a clear, sharp cut at the center of the work that introduces depth into an otherwise shallow pictorial space. Similarly, *Abstraction Blue* (1927) is dramatically bisected by an abrupt white line that widens as it shoots upward. On each side of the line are billowing veils

[5] O'Keeffe letter to William M. Milliken (1930) in Cowart, Hamilton and Greenough 1987, p. 202.
[6] O'Keeffe letter to Henry McBride (1929) in Cowart, Hamilton and Greenough 1987, p. 189.

of translucent blue, green, purple, and pink that seem to evaporate as they rise toward the top of the canvas. The overlapping edges of the egg-shaped forms are clearly defined at the bottom of the painting, but they do not align at the central cleavage, suggesting that O'Keeffe's atmospheric colors have been physically split into two parts.

O'Keeffe's subsequent paintings emerged from her exhilarating response to the New Mexico landscape that she first visited in 1929: "I never feel at home in the East like I do out here—and finally feeling in the right place again… It is just unbelievable—one perfect day after another."[6] For the next twenty years she traveled almost every year to summer in New Mexico, and returned to New York during winter, until she moved permanently to New Mexico in 1949, three years after the death of her husband, Alfred Stieglitz. O'Keeffe's paintings were now inspired by desert themes, including bleached bones, desert landscape, churches and buildings—but she continuously observed abstraction in nature. For instance, *Rust Red Hills* (1930) appears to be bold, abstract, horizontal gestures in brown, black, and red—until the title reveals the subject. The painting displays rounded un-

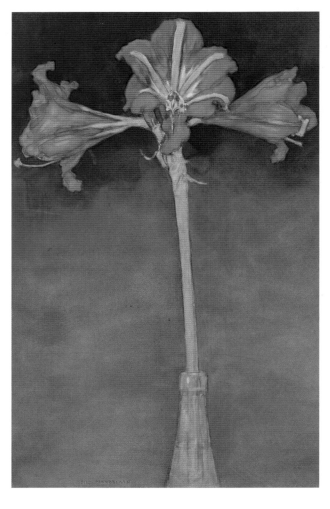

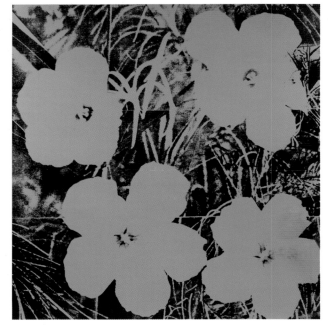

Piet Mondrian, *Red Amaryllis with Blue Background*, c. 1907
Watercolor on paper
18 3/8 × 13 inches (46.5 × 33 cm)
Museum of Modern Art (MoMA), New York
The Sidney and Harriet Janis Collection. Acc. no.: 1773.1967

Joseph Stella, *Neapolitan Song*, 1929
Oil on canvas
38 3/8 × 28 1/4 inches (97.5 × 71.7 cm)
Smithsonian American Art Museum, Washington, DC

Andy Warhol, *Ten-Foot Flowers*, 1967
Synthetic polymer paint and silkscreen ink on canvas
115 × 115 inches (292.2 × 292.2 cm)
Museum of Modern Art (MoMA), New York
Nina and Gordon Bunshaft Bequest Fund, Blanchette Hooker Rockefeller Fund (by exchange) and the P&S Committee Fund.

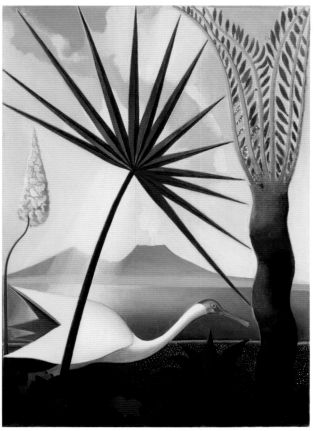

dulating forms of layered hills, divided by shifts in light and darkness that confuse reading of flatness or depth, and illustrates the artist's personal perspective of the New Mexican hills. O'Keeffe described her affinity for this landscape: "The red hill is a piece of the bad lands where even the grass is gone. Bad lands roll away outside my door—hill after hill—red hills of apparently the same sort of earth that you mix with oil to make paint. All the earth colors of the painter's palette are out there in the many miles of bad lands."[7]

O'Keeffe was also attracted to the dried and bleached bones of desert animals found in the area. She saw them, collected them, and painted them as abstract forms—mysterious shapes containing white ovals against a blue background: "When I started painting the pelvis bones, I was most interested in the holes in the bones—what I saw through them... Sun-bleached bones were the most wonderful against the blue—that blue that will always be there as it is now, after all man's destruction is finished."[8] *Pelvis with Distance* (1943) presents a large bone fragment stretching across the entire surface of the painting, touching all four sides of the canvas. The shape is both jagged and smooth, light and dark, physical and ethereal. The background is painted in gradated shades of blue to white, with a darker blue band filling the lower one-eighth of the canvas. This bottom section is the only reference to a recognizable landscape, depicting a shallow, flat desert plain

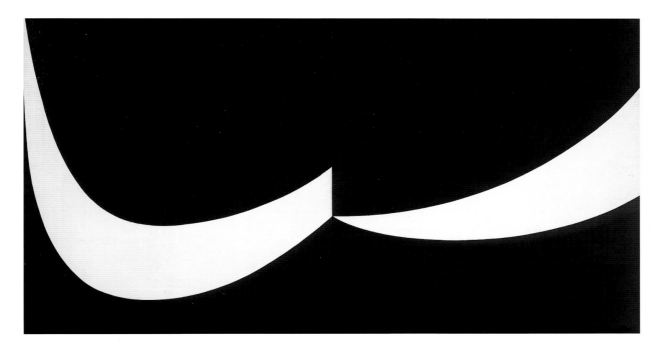
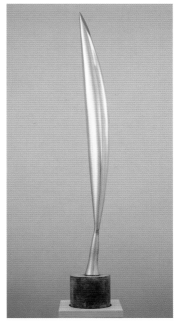

[7] O'Keeffe statement in "Georgia O'Keeffe: Exhibition of Oil and Pastels" (1939), in Buhler Lynes 1999, vol. 2, p. 1099.
[8] *Georgia O'Keeffe* (1976) 1985, p. 74.
[9] Ibid., p. 79.
[10] Ibid., p. 82.

with the New Mexican mountains in the far distance. O'Keeffe's bone painting is related in concept, composition, and surreal-ness to Joseph Stella's *Neapolitan Song* (1929). Stella was a contemporary of O'Keeffe in New York, and his painting is also an homage to a beloved land. It depicts a palmetto leaf radiating across the surface of the painting with a view of his birthplace, the Bay of Naples and Mount Vesuvius, in the distance.

Around the same time, O'Keeffe experimented with sculpture that was influenced by her interest in the oval voids of pelvis bones and her collection of seashells. *Abstraction* (modeled in 1946, cast 1979–80) consists of three interlocking circles of varying thickness and density that swirl in stationary elegance. It is primarily a frontal sculpture that duplicates O'Keeffe's representation of bones against a saturated blue or orange background and emphasizes the negative and positive spaces equally. It is reminiscent of Constantin Brancusi's *Bird in Space* (1932–40), who like O'Keeffe, drew inspiration from the simple shapes of nature. O'Keeffe was moved by the beauty of simple shells, and has explained: "I have picked up shells along the coast of Maine—farther south, in the Bermudas and Bahamas I found conch shells along the pure sandy beaches… I have always enjoyed painting them—and even now, living in the desert, the sea comes back to me when I hold one to my ear."[9]

In 1955, O'Keeffe painted *Green Patio Door*, a painting of her adobe house in Abiquiu, New Mexico.

It is one of her sparest abstractions, consisting of three bands representing the blue sky, the adobe wall with a green door, and the grey ground. This painting, and the 1962 work *Sky Above White Clouds I*, are compositionally related to the abstractions that Mark Rothko was creating at the same time in New York, as seen in *No. 5/No. 22* (1950). She has said about the adobe house: "In 1929 I saw an old broken down house with a walled garden. It was a large pigpen. The house had a patio with that green door in the long wall on one side. The walled garden and the long wall with the green door made me decide that it was going to be my house. It took another ten years to get the place, but I finally got it from the church and now I live in it… I have painted the door many times."[10]

The door was also the subject of one of O'Keeffe's largest canvases, *Black Door with Red* (1954). In this painting, the wall and door have been reduced to bold, bright yellow and red bands of color punctuated by an ominous black square. Here, O'Keeffe is pushing her approach to abstraction further by eliminating any allusion to natural color or form, or any attempt at three-dimensionality.

For the rest of her career, the New Mexico landscape supplied O'Keeffe with an endless source of fascination and motivation. In *From the Plains II* (1954), she translates a vast expanse of New Mexico's open skies with a low horizon into an abstract

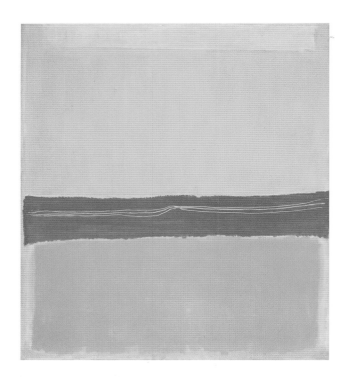

Mark Rothko, *No.5/No. 22*, 1950
Oil on canvas
116 × 107 inches
(297 × 272 cm)
Museum of Modern Art
(MoMA), New York.
Gift of the artist. 1108.1969

composition of brilliant red that is slashed by sharp, arching bolts of yellow lightening-like forms. The other-worldly quality of the painting is consistent with O'Keeffe's reaction to nature: "The unexplainable thing in nature that makes me feel the world is big far beyond my understanding—to understand maybe by trying to put it into form. To find the feeling of infinity on the horizon line or just over the next hill."[11]

From the Plains II is a larger, more abstract version of a work she completed in 1919, *Series I, From the Plains*. It also contains sharp, saw-tooth lightening bolts in blue, green, and white above an abstraction of dark, stormy skies—perhaps a remembrance of Lake George or the Texas plains where she previously lived. In her later version, O'Keeffe has rendered the New Mexico landscape in a hard edge manner in flatly painted expanses of color that recalls Ellsworth Kelly's depiction of light and shadow falling across the curved pages of an open book in *Atlantic* (1956).

A related group of paintings was provoked by her first experience of flying above the earth in the late 1950s. Her aerial perspective allowed a new interpretation of the landscape as seen from above, emphasizing flatness, light and dark, and the meandering shapes of rivers: "I once spent three and a half months flying around the world. I was surprised that there were so many desert areas with large riverbeds running

through them… Later I made paintings from the charcoal drawings. The color used for the paintings had little to do with what I had seen—the color grew as I painted."[12]

This observation encouraged O'Keeffe to interpret the shapes and forms she had seen from above and to express the remembered event in colors, as seen in titles such as *It Was Blue and Green* (1960). The painting depicts meandering curves of varying widths that do not suggest depth or perspective. Her interest remains with the colors and forms suggested by an aerial view of the landscape. O'Keeffe continued to pursue this vision and created some of her most sublime and abstract works, such as *Winter Road I* (1963). Here she is not looking directly down on the landscape, but presenting an oblique view of an irregular, curving, linear shape of dark brown that moves itself from the lower left to the upper left of the canvas against a stark white ground. O'Keeffe has described her approach: "It was accidental that I made the road seem to stand up in the air, but it amused me… The trees and the mesa beside it were unimportant for that painting—it was just the road."[13]

The title indicates that this abstraction is a road in winter, but it is sympathetic with the aesthetic position of other artists who derive inspiration from the natural world. Henri Matisse and Willem de Kooning, in particular, transformed their view of nature into abstract compositions of color and shape. Matisse's *The Yellow Curtain* (c. 1915) is not about the curtain—the curtain is actually a patterned red fabric with a yellow lining. Matisse's actual attention is focused on the landscape outside the window frame that consists of large blue and yellow biomorphic shapes. Similarly, de Kooning's *Pink Landscape* (c. 1938) presents yellow, red, green, and white rectangular and oval forms on a bright pink background to signify features of an imaginary or observed landscape.

Two of O'Keeffe's later paintings continue her approach to simplified landscape. *Canyon Country* (c. 1965) reduces vertical hills and horizontal desert floor to flat slabs of minimally modulated color. The brown hills have been transformed into truncated triangular shapes with sharp cuts and dark recesses, and the ground is con-

[11] Ibid., p. 100.
[12] Ibid., p. 103.
[13] Ibid., p. 104.
[14] Ibid., p. 88.

Henri Matisse, *The Yellow
Curtain (Issy-les-Moulineaux)*,
1915
Oil on canvas
57 1/4 × 38 1/8 inches
(146 × 97 cm)
Museum of Modern Art
(MoMA), New York
Gift of Jo Carole and Ronald
S. Lauder; Nelson A.
Rockefeller Bequest. Gift
of Mr. and Mrs. William
H. Weintraub, and Mary Sisler
Bequest (all by exchange)
Acc. no.: 355.1997

Willem de Kooning,
Pink Landscape,
c. 1938
Oil on composition board
25 × 37 1/8 inches
(63.4 × 94 cm)
Courtesy Matthew Marks
Gallery, New York

densed into three horizontal bands of muted color. In comparison with her more representational *Rust Red Hills* (1930), *Canyon Country* is extremely frontal, depicting a shallow space, and restricting the vastness of the New Mexico landscape into a closely cropped composition of form and movement.

Further limiting recognizable imagery, in *From a Day with Juan II* (1976–77), O'Keeffe presents an imposing, vertical trapezoid that dominates the center of the canvas. It seems to rise from the bottom of the canvas and become slightly narrower and darker as it ascends to the top. The faint blue background suggests a sky, so that the foreground might allude to a thick adobe wall of her home, as seen previously in *Wall with Green Door* (1952), or express a poetic interpretation of her failing vision, or simply record the visual memory of a day spent with Juan. Although more austere and solemn, this late painting recalls O'Keeffe's earliest

abstractions of the late 1910s and early 1920s that featured purely abstract color and form that seem to ascend from the lower canvas and expand upward, creating an impressive vision of solidity and monumentality. The work that O'Keeffe created over fifty years remains consistent and clear, with recurring themes, colors, and forms that trace her emotional and physical life through the expression she loved most—painting abstraction from nature.

"It is surprising to me how many people separate the objective from the abstract. Objective painting is not good painting unless it is good in the abstract sense. A hill or tree cannot make a good painting just because it is a hill or a tree. It is lines and color put together so that they say something. For me that is the very basis of painting. The abstraction is often the most definite form for the intangible thing in myself that I can only clarify in paint."[14]

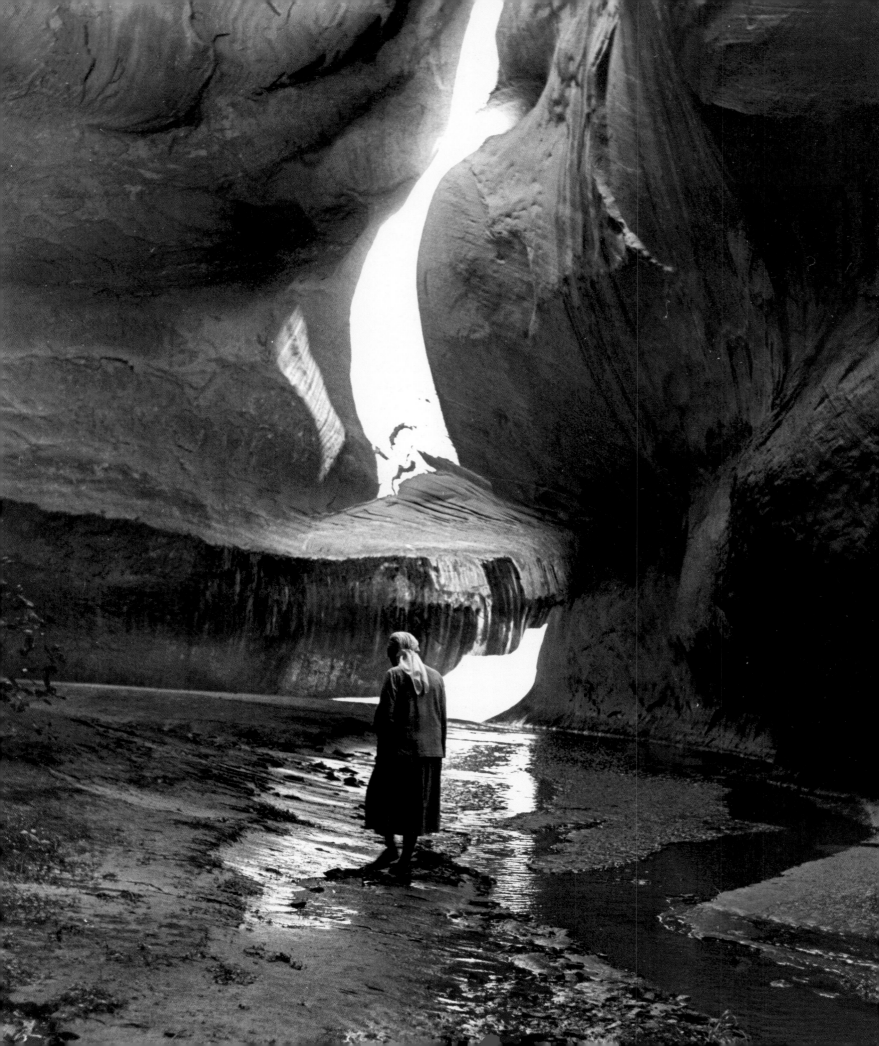

Yvonne Scott

Georgia O'Keeffe's Landscapes: Modern and American

Todd Webb, O'Keeffe
Walking in Twilight Canyon,
1964

A major exhibition in Ireland of an internationally acclaimed artist of Irish ancestry inevitably raises the question of the possibility of cross connections and influences—particularly in the case of Georgia O'Keeffe with her reputation as a landscape painter. On the face of it, there is no obvious link between her work and that of her Irish contemporaries, at least in the earlier decades of her work to mid-century. However, there are certainly aims in common during a period when O'Keeffe's definitive characteristics emerged. In particular, she succeeded in articulating imagery that is acclaimed as both Modernist and American. This achievement has parallels with what several key artists, like Jack Yeats, Mainie Jellett and Paul Henry, were also attempting in Ireland around the same time, and in common with many artists in other countries. Much has been written about the challenge of combining the apparently opposing concerns of Modernism and cultural nationalism/regionalism, with their respective avant-garde versus traditional perspectives. Ireland, post-Independence (from 1921–22) was caught at the cross-roads between the desire, on one hand, to reclaim an exclusive, native, pre-colonial cultural identity, and on the other, to participate as an equal in a progressive contemporary world: one aim meant looking to the past, the other to the future. It might seem that America, long politically independent, with its industrial development, high-rise cities, and legendary wealth, would have no difficulty with the Modern aspect. However, O'Keeffe's formative years took place in a country whose contemporary visual expression was seen to be upstaged by Europe, particularly since the Armory Show of 1913, celebrated for bringing together the cutting-edge art of the Western world.[1] O'Keeffe's vision was a breakthrough for an American form of Modernism and she has recently been described as apparently "without progenitors," in deference to her originality.[2]

While her Modernism extended to all of her themes, the distinctively American dimension was vested primarily in O'Keeffe's landscapes. She grew up in rural Wisconsin, lived for some time in New York, but spent most of her adult life in the south-western United States, initially in the panhandle area of Texas and then in New Mexico which she visited annually and where she later settled. She also regularly visited Lake George, where the holiday home of the family of her husband, Alfred Stieglitz, was located. Her response to the landscape was deeply rooted in a sense of place, and recent research has identified over sixty of the locations that she recorded with a remarkable, if highly selective, faithfulness to the original.[3] As Barbara Buhler Lynes points out, while O'Keeffe transcribed the contours of the landscape forms with literal accuracy, she took liberties with scale.[4] In addition, surface details, like shrubbery, might be omitted from the image to reveal the underlying structure of the landscape, and colour was freely interpreted as she experimented with the abstract possibilities of nature.

[1] Robert Hughes, *American Visions* (London: Harvill Press, 1997), p. 393.
[2] Hal Foster, Rosalind Krauss, Yve Alain Bois, and Benjamin H.D. Buchloh, *Art Since 1900* (London: Thames and Hudson, 2004), p. 225.
[4] Ibid., p. 16.

Recognition of place is essential for a sense of national or regional identity, either through the familiarity of a specific location or through typicality. The latter is often represented by artists through traditional cultural motifs, as for example the ubiquitous thatched cottage in Irish paintings in the 1920s and 30s.[5] Such a strategy was difficult to reconcile, however, with the progressive tenor of Modernism and it is notable that O'Keeffe's landscapes are typically devoid of all human presence, and only rarely incorporate man-made features. Where they do, it is as much for their abstract qualities of form and colour as for their functional or narrative possibilities: *Winter Road I* (1963) is presented as a calligraphic sweep, the Ranchos Church series such as *Untitled (Ranchos Church)* (1929) a cubistic analysis of volume and tone, and *Black Door with Red* (1954) —if a segment of a building can be considered as part of landscape—is a proto-minimalist exercise. In addition, such structures seem embedded in the landscape; the course of the road, like a river, is determined by the contours of the landscape; the adobe buildings are moulded from the sun-baked clay of the earth, and could crumble back into it. The result is that while she consistently presents landscapes that are familiar, they could belong to any time: past, present or future. Thus their Modernism and their American identity are compatible from a temporal perspective.

While there is little doubt that O'Keeffe's work broke new ground in various ways, the observation that she seemed to have no progenitors needs some qualification. Charles C. Eldredge and John Wilmerding have each identified a range of artists and writers whose work was familiar to O'Keeffe, or informed the cultural environment within which her landscape perspective developed.[6] Eldredge points out that her isolation of natural objects and intense focus stemmed from a tradition of observation of nature that was a central aspect of American thought at least since the nineteenth century, encapsulated in the writing of Frank Waldo Emerson and Henry David Thoreau and developed by countless others. She was responsive to Walt Whitman's poetry with its references to the land, the body and nationality and to D.H. Lawrence's writing set in New Mexico. Lawrence's novella *St. Mawr*, published in 1925, is set around a central character whose redeeming exposure to the vitality of nature bears uncanny resemblance to O'Keeffe's experience.

Among painters, Thomas Cole and the Hudson River School preceded O'Keeffe in encapsulating a contemporary image of the nation through landscape. Their sublime vistas of untamed wilderness, of soaring cliffs and dense forests peopled by native tribes supposedly unspoiled by civilization, turned America's perceived comparative lack of history and culture—by narrow and insular European standards—into a virtue. Stephen Daniels points out that writers of the mid-nineteenth century saw landscape "not just as a setting for events but as a vehicle to articulate social and moral issues."[7] Cole, in his *Essay on American Scenery* published in 1836, lamented the "ravages of the axe" where "the most noble scenes are made desolate, and often with a wantonness and barbarism scarcely credible in a civilized nation."[8] Forests were levelled to clear the land and to fuel industry and Barbara Novak explains that the cut tree-stump in Cole's paintings "suggests a new iconology of progress and destruction."[9]

O'Keeffe's regular visits to Lake George, one of the chain of lakes fed by the Hudson River, presented her with plenty of opportunities to paint the glories of nature, but she did so without any overt moralizing. Like her Hudson River School predecessors, she painted trees, but rarely depicted the entire structure, let alone a forest, focusing instead on the smooth and sinuous trunks, and editing out the tree canopy and sometimes also the base. In some examples, the density of forest is indicated where the pale trunk stands out against the mass of dense foliage, indicated rather than detailed, as in *Birch Trees* (1925). Such close focus and cropping was at least partly for compositional purposes, to develop the abstract qualities of such an arrangement, and O'Keeffe's notes on one of this series seems to bear this out[10] but there is the intrinsic recognition of the vigorous, even sinister, power of nature that will emerge more decisively in her New Mexico landscapes, like *D. H. Lawrence Pine Tree* (1929). O'Keeffe's image reflects the writer's description of the great pine that stood outside the ranch house where he stayed, and that O'Keeffe later visited. He wrote of the green top that one never

[5] Some of the best examples can be seen in the work of Paul Henry and Gerard Dillon, but there was a tendency among many artists for the imagery to become formulaic.
[6] See Charles C. Eldredge, *Georgia O'Keeffe: American and Modern* (London: Yale University Press, 1993); and John Wilmerding, "Georgia O'Keeffe and the American Landscape Tradition," in Joseph S. Czestochowski, ed., *Georgia O'Keeffe: Visions of the Sublime* (Memphis: The Torch Press and International Arts, 2004), pp. 13–52.
[7] Stephen Daniels, "Thomas Cole and the Course of Empire," in *Fields of Vision* (Blackwell, 1993), p. 151.
[8] Quoted in ibid., p. 157.
[9] Barbara Novak, *Nature and Culture: American Landscape and Painting 1825–1875* (New York and Oxford: Oxford University Press, 1995), p. 161.
[10] "A little way from the dock there was a big old birch tree with many trunks." Georgia O'Keeffe, *Georgia O'Keeffe* (New York: Viking Press, 1976), unpaginated.

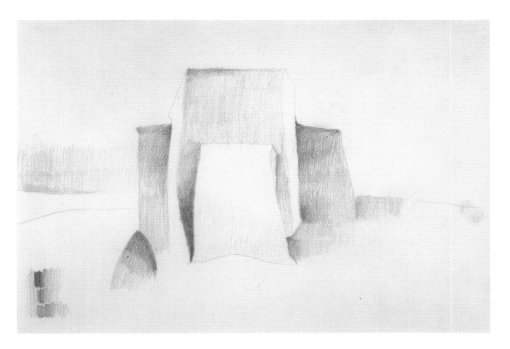

Georgia O'Keeffe
Untitled (Ranchos Church),
1929
Graphite on paper
6 ⅝ × 10 inches
(16.8 × 25.4 cm)
The Georgia O'Keeffe
Museum, Santa Fe

[11] D.H. Lawrence, *Mornings in Mexico* (first published 1925) reprinted in *Mornings in Mexico* and *Etruscan Places* (Melbourne, London and Toronto: William Heinemann Ltd., 1956), p. 81.
[12] O'Keeffe 1976, unpaginated.
[13] Novak 1995, p. 40.
[14] Daniels 1993, p. 169.
[15] As Barringer has pointed out, "[c]omparisons between past and present—both optimistic and pessimistic—were a commonplace of nineteenth-century thought." Tim Barringer, "The Courses of Empires; Landscape and Identity in America and Britain, 1820–1880," in Andrew Wilton and Tim Barringer, *American Sublime*, exhibition catalogue (London: Tate Publishing, 2002), 39–65 (p. 52).

looks at, and the trunk "like a guardian angel."[11] This symbolism of protection is conveyed by her viewpoint, generated by her supine position under the aegis of canopy which she described: "I often lay on that bench looking up into that tree … past the trunk and up into the branches. It was particularly fine at night with the stars above the tree."[12]

O'Keeffe only occasionally addressed water which was also a staple of the Hudson River School repertoire. For them its power and abundance was a potent symbol of the American landscape, whether conveyed through sublime waterfalls or immense, still lakes. Still water, as Novak explains in relation to nineteenth-century American painting, "symbolizes a spirit untroubled in its depths, and unifying both surface and depth in its reflection of the world above."[13] While O'Keeffe's representations of Lake George explore both calm and dynamic aspects, they are less about universal, paternalistic messages than a desire to convey a deeply personal experience of nature through abstracted, experimental representations, as seen for example in the calm *Lake George* (1922) and the intensely troubled and turbulent *From the Lake, No.1* (1924).

However significant the environment of Lake George for her studies of nature, it was her beloved New Mexico that inspired her most definitive and original approach to landscape. Daniels has noted the

"Western trajectory of national identity" as the nineteenth-century painters fell out of fashion, even before O'Keeffe's move there.[14] In contrast to the verdant wildernesses of the Hudson School, it was the severe and barren badlands of the desert that distinguished O'Keeffe's landscape images, like *Rust Red Hills* (1930) and *Black Place I* (1944), and enabled her to redefine the American landscape for a contemporary audience. While O'Keeffe, like the earlier prototypes of nationalist landscape, addressed the primitive, their dependence on the "noble savage" personified by the indigenous populations were an unwitting affirmation of a white colonial mindset. O'Keeffe's primitivism was based in a non-developed landscape, not people.

Unlike Cole's threatened environments, O'Keeffe's appear impervious; there is no suggestion that they are endangered, whatever the reality may be in fact. With no moral connotations or sense of fragility, they appear suspended in time, and consequently timeless, a reassuring image for a country recovering from the ravages of economic depression. In the desert images, the light is often universal, casting no shadows but intensifying colour, particularly of the sky. In comparison to nineteenth-century interpretations with their preference for dawn and dusk, and all that infers for the beginning or end of civilization,[15] O'Keeffe's light, if its source can be inferred, generally emanates from overhead, suspending the landscape in a permanent present.

Time is an underlying leitmotif across much of her work. The relatively early "waves" series of 1922 may carry connotations of Shakespeare's adoption of the image as a metaphor for the relentless passing of time, but she seems less concerned about the inevitable end of individuals than the continuity of nature. The river theme appears from time to time in particular in her late work where a high perspective allows her to chart its passage across a landscape without horizon, as in *It was Blue and Green* (1960). While the arid landscape predominates, the role of water in its formation is evident, particularly in the canyon works. *Cliffs beyond Abiquiu, Dry Waterfall* (1943) is indicative of her interest in the relationship between movement and time, and the slow evolution in the formation of the ancient landscape she favoured. As Sharyn Udall has explained, "O'Keeffe did not grow up

near large bodies of water, and her first important responses to landscape arose out of the places from which the generative power of water had long departed, leaving its traces on eroded, bare landforms. In the Palo Duro Canyon of west Texas the young O'Keeffe drew and painted hills that had been sculpted by wind and long-vanished water—scoured red canyon walls beneath which only a trickle of water might remain."[16] Lynes has noted in New Mexico the "vast panorama of contrasting forms and colors shaped over millions of years by water and wind erosion."[17]

Some of the waterfall images, however, like the flower paintings, suggest references to the body, a reminder of the essentially organic, mutable quality of even the most obdurate geology, as seen in *Waterfall I* and *Waterfall II* (both 1952). These and other works are directly comparable to some of the flower paintings in their close, cropped focus, and references to the body and sexuality. The land had long been associated with womanhood, but rarely addressed by a female artist, particularly in such exploratory and revealing ways, and O'Keeffe's sensitivity to how such imagery was reviewed was understandable. Lynes has noted that the artist's work in New Mexico, with its marked associations with the specificity of place, was related to a desire to avoid intrusive commentary.[18] However, there were exceptions. The association of landscape and the female body is most commonly derived from notions of fertility, so the connection of a life enhancing force with the desert is unexpected, at least to those unfamiliar with its nature and cycles. However, the contours of the landscape, laid bare by sparse foliage, characterized by anthropomorphic form and by crevices opening to reveal glimpses of internal structures and complex layers, presented new perspectives on the parallels within nature.

O'Keeffe's unusual perspective is particularly notable given the more common association of the desert with death, as observed by Yi-Fu Tuan,[19] based in the widespread perception of a barren landscape devoid of sustenance, and the surreal extension of seemingly infinite space. The temporal elements in O'Keeffe's work together with the recurrent motif of bones in an arid landscape seem also to invite this association. However, in effect there is little that is elegiac in this phase of her

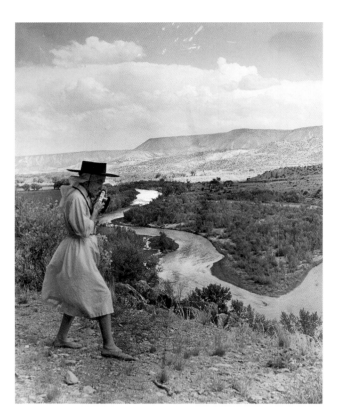

Todd Webb, O'Keeffe Photographing at the Chama River, New Mexico, 1961

work, and her comments about bones give no indication that she dwelled on death as finality. Hunter Drohojowska-Philp reads the images of skulls and flowers floating in the sky as representing the artist's symbolic resurrection when she returned to painting following an eighteen-month hiatus due to a nervous breakdown.[20] O'Keeffe mentions the presence of bones in her home as a matter of course, how she handled them regularly from childhood, fascinated by their abstract forms. While she clearly associated them with the terrain in which she found them, they represented for her the fascination of nature in the present and explain perhaps her regular inclusion of perfect flowers in her bone pictures: "When I found the beautiful white bones on the desert I picked them up and took them home … I have used these things to say what is to me the wideness and wonder of the world as I live in it."[21]

The presence of the white bones in the landscape infers the burning desert sun which bleached them, and the relentless expanse of sky. O'Keeffe recalls: "…when I started painting the pelvis bones I was most interested in the holes in the bones—what I saw through them— particularly the blue from holding them up in the sun against the sky as one is apt to do when one seems to have more sky than earth in one's world."[22]

[16] Sharyn R. Udall, "Nature after God: Waterfalls in the American Modernist Imagination," in Czestochowski, ed., 2004, pp. 53–62 (p. 60).

[17] Barbara Buhler Lynes, "Georgia O'Keeffe and New Mexico: A Sense of Place," in Buhler Lynes, Poling-Kempes and Turner 2004, pp. 11–58 (p. 12).

[18] Ibid., p. 11.

[19] Yi-Fu Tuan, "Desert and Ice: ambivalent aesthetics," in Salim Kemal and Ivan Gaskell, eds., *Landscape, Natural Beauty and the Arts* (Cambridge University Press, 1995; first published 1993), pp. 139–157 (p. 146).

[20] Hunter Drohojowska-Philp, *Full Bloom: The Art and Life of Georgia O'Keeffe* (New York and London: W.W. Norton, 2005; first published 1995). Caption to illustrations, unpaginated.

[21] Appendix If. Statement from Georgia O'Keeffe: Paintings–1943. Exhibition brochure, *An American Place* (New York, 11 January–11 March 1944), in Barbara Buhler Lynes, *Georgia O'Keeffe: Catalogue Raisonné* (New Haven: Yale University Press; National Gallery of Art, Washington, DC; Georgia O'Keeffe Foundation, Abiquiu, New Mexico, 1999), p. 1099.

[22] Ibid.

She links these elements directly in works such as *Pelvis with Distance* (1943) and *Pelvis I* (1944) where the circle of bones becomes a framing device to draw attention to the infinite depth rather than breadth of the sky.

While skies are generally shown as a plane of primary colour, clouds appear in her work from time to time, influenced perhaps by the photography of her husband, Alfred Stieglitz, who was interested in atmosphere, seeking tone and texture in a black and white medium. His photographs are thought to have prompted such works as *A Celebration* (1924) highlighting the abstract potential of images entirely of sky and devoid of devices to frame the image or orientate the viewer. Such *di sotto in su* perspectives could potentially be hung in any direction, as there is no top or bottom to the image, in the traditional sense, emphasizing the abstract quality of particular viewpoints.

Clouds featured again in her patio series of the 1950s, where the sky was framed by the surrounding building, but they became especially significant in a series of late works suggested by the perspectives afforded by air travel. In particular, O'Keeffe responded to the disorientating vista above the clouds when she was looking down, instead of up at them, and they appeared like stepping stones as in *Above the Clouds I* (1962–63) and *Sky Above Clouds IV* (1965). The latter is an enormous version, over seven metres (24 ft) long, carried out with some practical difficulties when she was 78 years old, but still experimenting. Another version, *Sky Above White Clouds I* (1962), shows the artificial horizon created by a blanket of cloud as seen from the air, and the abstract aesthetic it produces. The horizon normally acts not only as an orienting device for the viewer, but also as a symbol of aspiration; as the edge of the visible world, it represents the shifting boundary between the visible present and the occluded future. However, in O'Keeffe's cloudscapes, the vista beyond the horizon will be identical to that seen, and the image dissolves into abstraction both spatially and conceptually.

While O'Keeffe's creativity did not emerge from a vacuum, it is understandable that she should be seen as having no obvious progenitors given the extent to which she redefined the American landscape as a resolution of opposites: of life and death, of focus and infinity, of nature and culture, originality and familiarity, of the native and the foreign. Her landscapes present an intensely personal space that has relevance to a wide audience, within and beyond the horizons of America.

Her perspectives are illuminated by her observations, not least her comment about: "… [t]he unexplained thing in nature that makes me feel the world is big far beyond my understanding—to understand maybe by trying to put it into form. To find the feeling of infinity on the horizon line or just over the next hill."[23]

[23] O'Keeffe 1976, unpaginated.

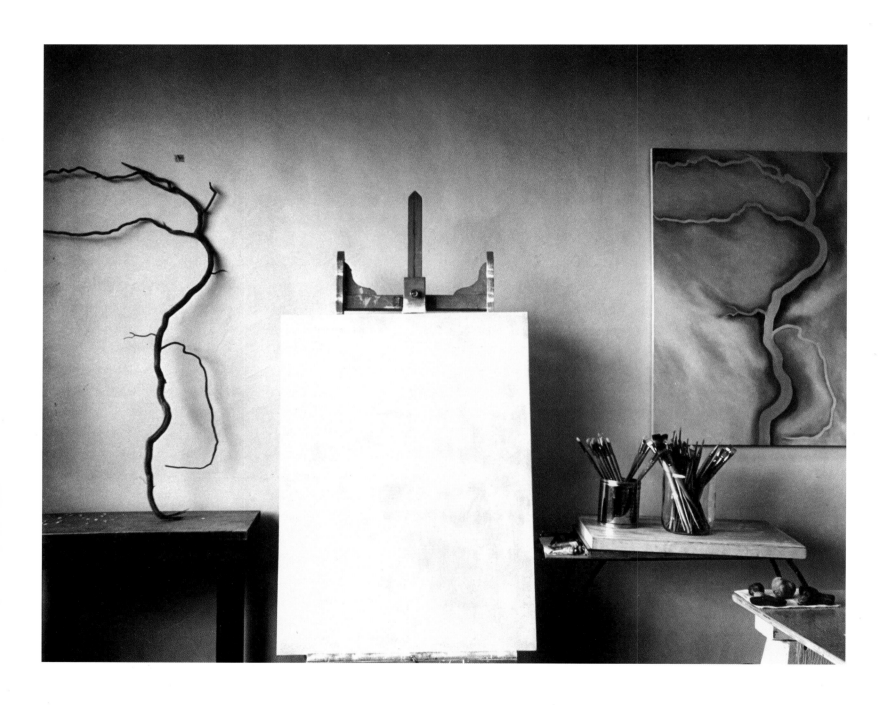

Achille Bonito Oliva

A Constellation of Forms

"We can therefore define art as the contemplation of things independently of the principle of reason, thus contrasting it with the kind of knowledge that obeys this principle, namely the path of experience and science. This second kind of knowledge is comparable to a horizontal line tending towards the infinite: art, instead, is like a perpendicular intersecting the other line at a freely chosen point. The first is like a violent hurricane that passes without its beginning and end being seen, flattening and devastating and sweeping away everything in its path. The second is the peaceful sunbeam that pierces the darkness of the hurricane and challenges its violence. The first is like the countless drops of a waterfall that cascade violently, taking on a thousand different shapes without an instant of rest. The second is the rainbow that arches serenely above this infernal commotion" (Plato).

What interests us in this definition is the "therefore," the quietly assertive fact of art as experience ultimately set free by the form it acquires, the manifest side of an observation true both of the artist who initiates the creative experience and the spectator who surveys the result from a distance.

Georgia O'Keeffe's work, from 1918 on, has always played on a *knowledge forgotten by heart*, a creative process that values to the utmost the choice of tools and their application, which reaches for an objective result. The artist is the author of a paradoxical project of creation hinging on the anxious watchfulness of techniques and the abandon of the hand steeped in memory.

Memory is not a catalogue of instructions for use but rather a deep well of propulsions, of forms stratified and dispossessed with respect to their creator and later rendered in their energetic configuration on the painting's surface.

O'Keeffe's painting relied initially on the arrangement of abstract forms highlighted on the canvas with the constructive force of a sort of organic architecture, made by violating the rigidity of geometry and instead favouring shapes in the round. Spirals with a concave-convex rhythm, deep bends jostling in space are evidence of a vision of art capable of founding a different nature of forms, painting as Matter, as an interior cavern with elastic boundaries.

While the boundary arises from the artist's need to come up with a gauge confining the gesture, elasticity in turn obeys the impulse to avoid imposing rigidity and repression on forms concerned with the mental and physical depth of space.

Colour serves to accentuate this tension and certainly not to comment expressionistically—in accordance with the dictates of pure subjectivity—on the work's internal dialectics. Even the proverbially dramatic colour black supports the need to emphasize the energetic character of a construction tending toward the internal more than the external.

In this way O'Keeffe anticipates colours and forms

belonging to northern Expressionism and North American gestural painting, through the foundation of a pictorial architecture capable of basing its own value on reasons inherent in the construction itself. The preferred form is circular or spiralling, melding movement and momentum, the outbound and inbound, an uninterrupted flow of the sign of colour that borders on the rhythms of historical abstractionism as well as the volume of an abstract-concrete structure.

The opacity of this substance is what makes any reference to external forms impossible and stabilizes all the tension within the boundary of the work. This concreteness is made more evident by the deep psychic substance of the forms, which clearly tend toward a dimension steeped in Mediterranean culture, composed of airy containment but certainly not of rigid implosion.

O'Keeffe's work experiments with procedures that can enhance these configurations by being open to the transformation of matter through the interplay of the natural element in accordance with a precise temporal order. The work is the result of an arrangement of elements placed in contact with one another—colours extracted from plants, light, earth—and then caused to react with the aid of a temporality capable of generating transformative effects.

In this sense, art becomes the "contemplation of things," of things not previously belonging to the inert universe of everyday life but which are the result of an auxiliary intervention, of an open project initiated by the artist. Chance also plays a part in the work as an element of construction already foreseen and not as a source of disruption.

While the abstract substance of such forms appears to lose their initial sense of organic architecture, made up of shapes that develop and envelop one another, they nonetheless gain in terms of horizontal dilation and allusions to a possible overstepping of boundaries.

The work is now produced by the artist with the impetus of knowledge which, however, happily succeeds in losing its executive lucidity through abandonment to organic forms with the stratification and broad sweep of the landscape.

O'Keeffe's interior landscapes are not instinctual, the emotional traces of an emotive catastrophe, but rather the

Todd Webb, Patio Door, O'Keeffe's Abiquiu House, 1977

effect of the consolidation of a catastrophe as procedure, capable of playing on a memory of forms that is consolidated, and hence depersonalized, yet fortified by the subject's abandonment of every existential residue. Here the subject operates through its ability to place itself at the service of a reality that becomes more deeply internal the more it succeeds in consolidating itself externally through the founding of an objective form, which finally means belonging to the collective memory.

O'Keeffe replaces the catastrophe with Plato's hurricane and the telluric fragments with the "countless drops" that spread out on the canvas and expand within the concreteness of forms that preserve the rapidity of the fall, the liquid capacity of penetration, the oily sense of expansion. Of the hurricane of creation, forgotten by heart, no trace remains if not the stratified interweaving of its movement, the accompanying rhythm of shapes that bend towards one another, caverns that are elastic and resonant yet soundproofed by the rigorous two-dimensionality of the all-encompassing and all-dissolving surface.

Larval and antenatal in terms of colour and dilution, the forms anticipate the timbre of Rothko and the impetus of Kline, Morris Louis, and Louise Bourgeois.

They are deliberately antenatal as forms that must not and cannot belong to real life but rather pause on the pellicular threshold of painting in the pivotal condition peculiar to art. All these concrete forms are as though immersed in liquid and left suspended there, in a state of animal and vegetal indeterminacy that amplifies their potential. This potential is developed in the blare of the chromatic timbre, in the proliferation of darting forms that fuel the suspicion of another and further possible articulation, of an internal contamination capable of modifying the internal balance. In this way, what painting most forgets by heart is the author who deliberately produces chromatic and formal aggregations spread out smoothly and seamlessly over a surface.

The forms take on the stationary liquidity of a map, the interweaving of territories adrift or confined by the boundaries of the work, which tend to produce a slight compression at the edges of the peripheral shapes to propel them back into contact with the centre. Here there is no hierarchy between centre and periphery, vertical and horizontal, up and down, since the forms themselves are reconciled in an interweave that eliminates any clash, a skein of calm energies linked to one another by an oily silence. Explicit representations and material manoeuverings: a subtle interplay between applications of colour and flows of paint, as though the action lay in the betrayal of one by the other. The gestural violence of forms projected into a landscape of painting where it is possible to sense the nucleus in which cultural and imaginative work interlock, the physiological timing of the work and imaginary symptoms, which appear as shreds of the tissue of memory, like when we imagine things that are unprecedented but already seen and somehow experienced.

This painting founds the *art of intimating*, the capacity for seeing through the felicitous and prolific nebulosity of forms played out between knowledge and forgetfulness, memory and oblivion. Because art is simultaneously a threshold of approach and distance, a stopping point for the contemplation of internal forms that acquire the self-evident quality of the objective apparition. Georgia O'Keeffe's art is one of visual suspicion, caught between familiarity and extraneousness, the latter prompted by the estrangement of forms that certainly do not belong to the phenomenal visibility of everyday reality but rather to the sphere of deep experience hinging on a phantasmal reality.

In this way art becomes the practice of reinvention, the sphere of joyous remembrance that does not claim the arrogant rights of discovery but rather the pride of having unveiled forms that trigger the felicitously ambiguous and nebulous suspicion of collective belonging. These forms are the fruit not of a laceration, or of a despoilment made by a masculine cut, but of a determined and energetic backing for a positively feminine drive aimed at building a suggestion.

O'Keeffe's abstract and concrete landscapes are peremptory but not authoritarian, propositional but not impositional, capable of inducing contemplation that allows the body and the mind to surpass their own confines. Art is, in effect, not a matter of reconversion. Rather, as in all of Renata Boero's creative work, it's a biological shift toward impalpability through forms supported by a new gravitational principle: a gravity that reaches for the constellation above.

Works

"It was in the fall of 1915 that I first had the idea that what I had been taught was of little value to me except for the use of my materials as a language—charcoal, pencil, pen and ink, watercolor, pastel, and oil. I had become fluent with them when I was so young that they were simply another language that I handled easily. But what to say with them? I had been taught to work like others and after careful thinking I decided that I wasn't going to spend my life doing what had already been done."
Georgia O'Keeffe, *Georgia O'Keeffe* (New York: Viking Press, 1976), n.p.

1.
*Series I, No 4**, 1918
Oil on canvas
20 x 16 inches (50.8 x 40.6 cm)
Städtische Galerie im
Lenbachhaus, Munich

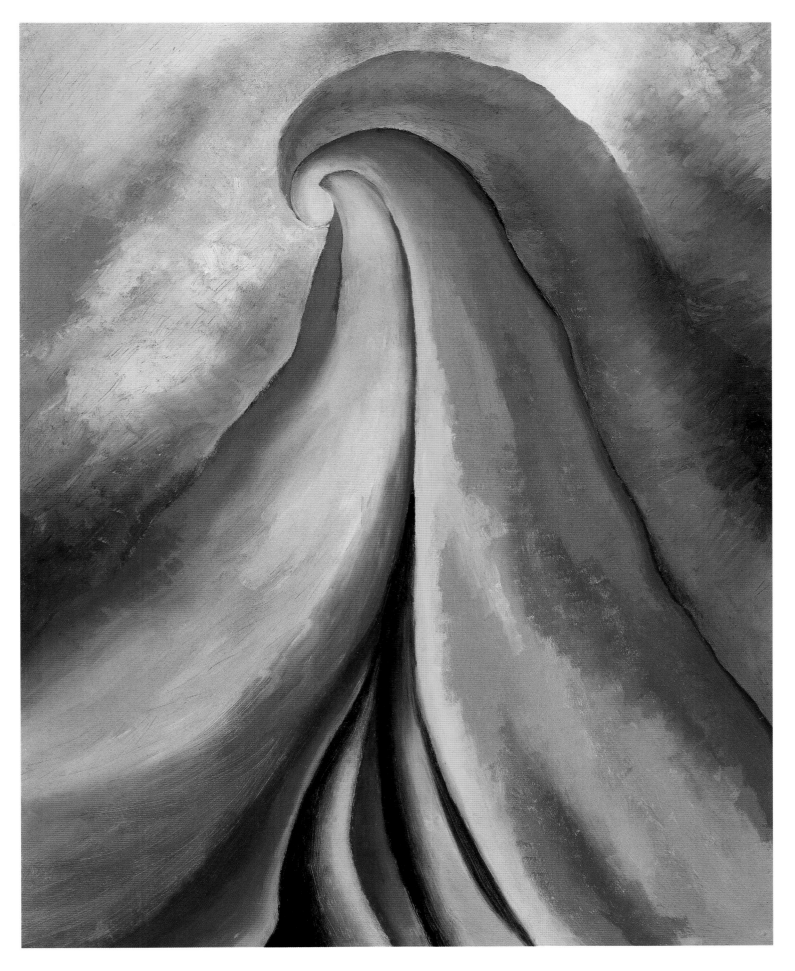

2.
*Untitled (Abstraction)**, 1918
Oil on canvas
19 x 14 inches (48.2 x 35.5 cm)
The University of Mississippi
Museum, gift of Seymour
Lawrence [1996]

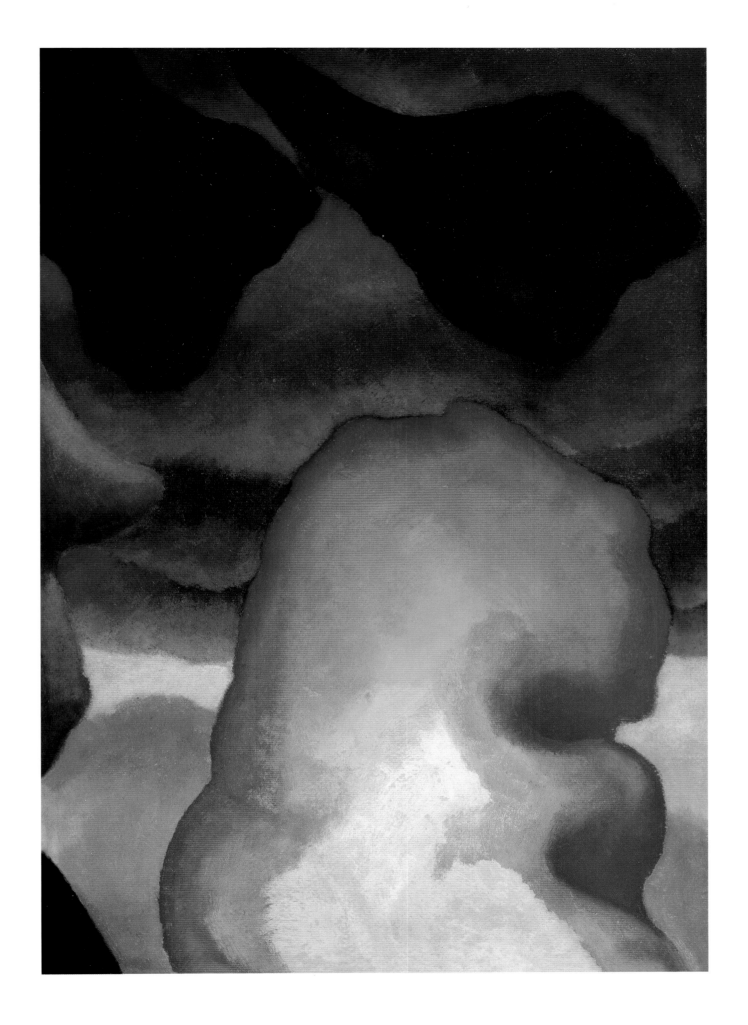

3.
Black Spot No. 3, 1919
Oil on canvas
24 x 16 inches (61 x 40.6 cm)
Albright-Knox Art Gallery,
Buffalo, New York
George B. and Jenny R.
Mathews Fund, and Charles
Clifton Fund, 1973

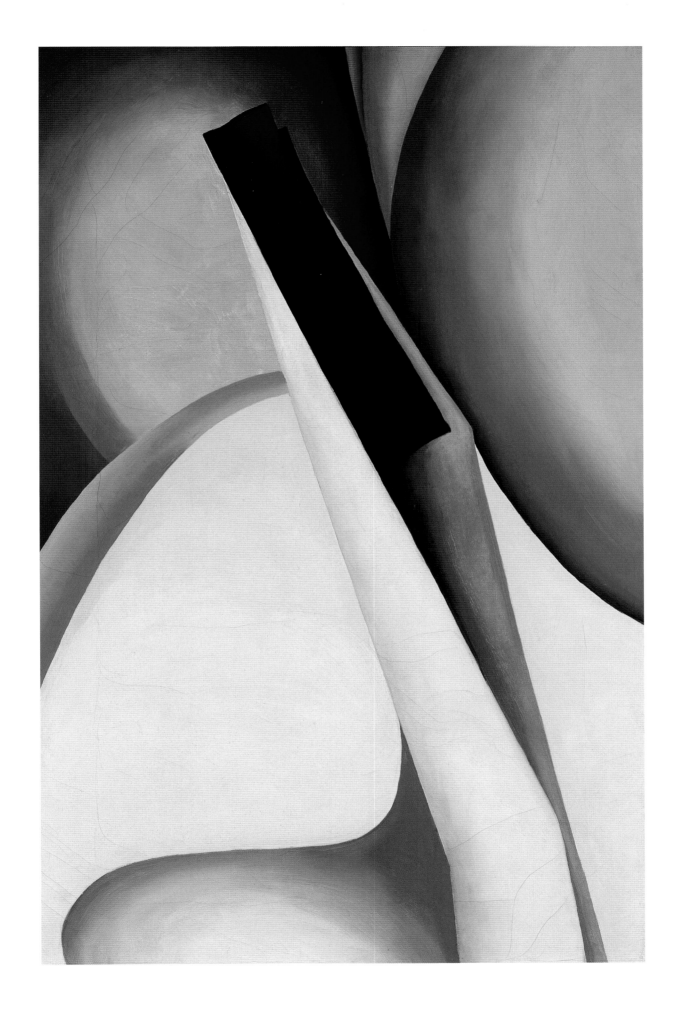

4.
Blue Line, 1919
Oil on canvas
20 1/8 x 17 1/8 inches
(51 x 43 cm)
Santa Fe, The Georgia O'Keeffe
Museum

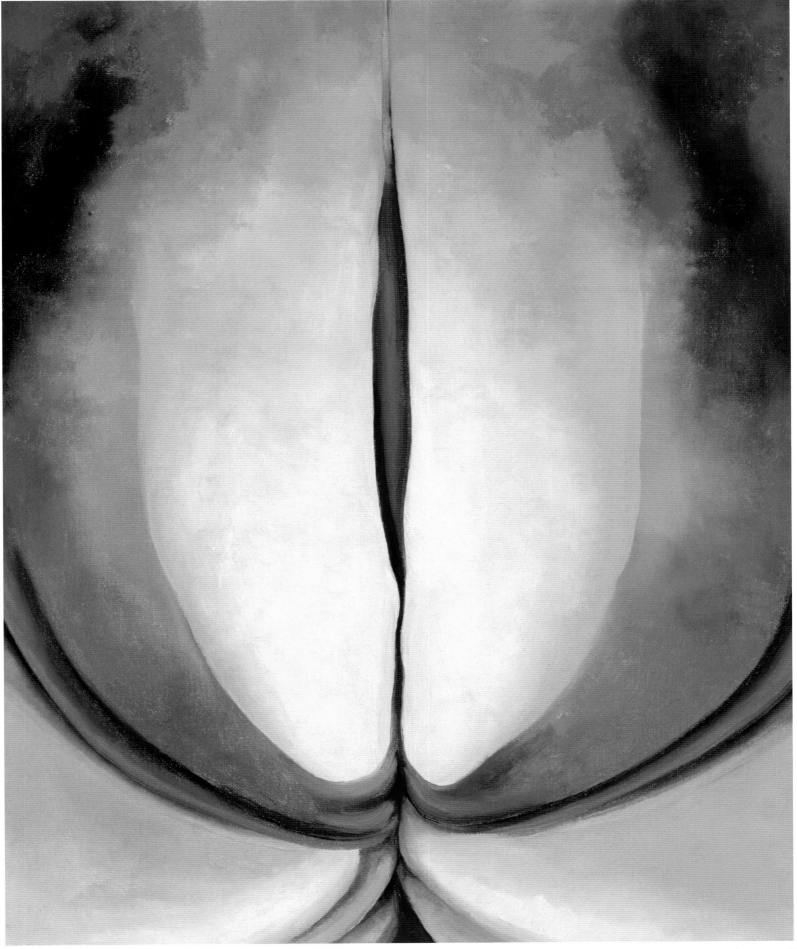

5.
Lake George, Coat and Red,
1919
Oil on canvas
27 $^3/_8$ x 23 $^1/_4$ inches
(69.6 x 59 cm)
New York, Museum of Modern
Art (MoMA). Gift of the Georgia
O'Keeffe Foundation.
Acc. no.: 65.1995

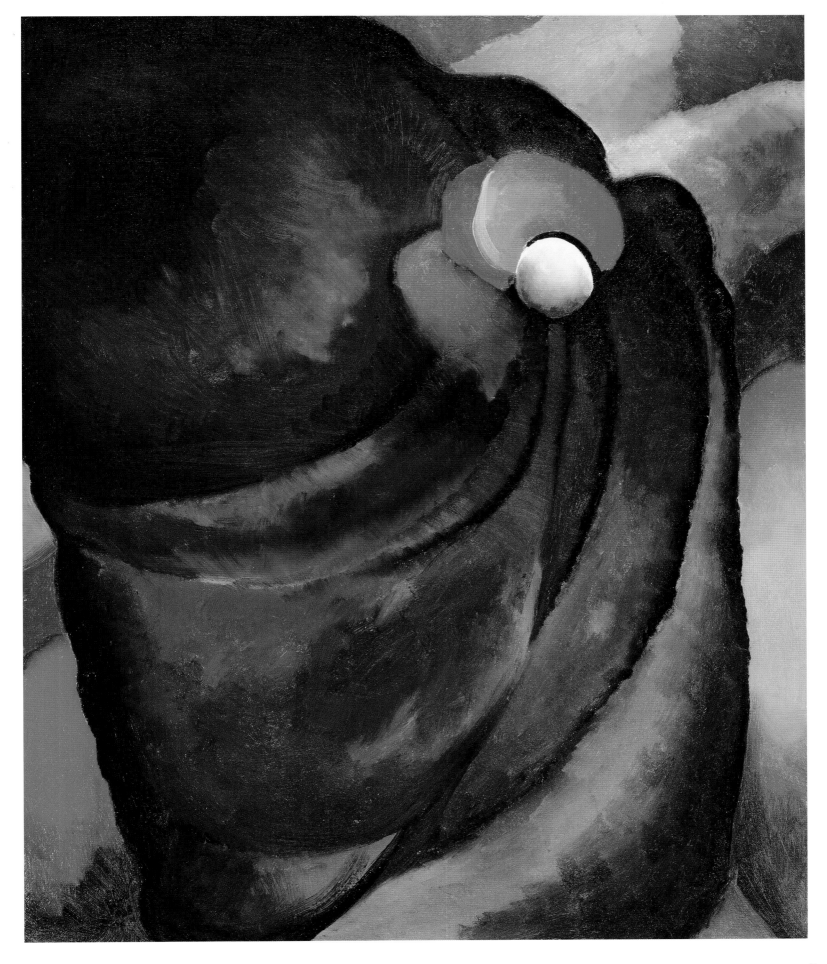

6.

Red and Orange Streak / Streak,
1919
Oil on canvas
27 x 23 inches (68.5 x 58.4 cm)
Philadelphia Museum of Art.
Bequest of Georgia O'Keeffe
for the Alfred Stieglitz
Collection, 1987

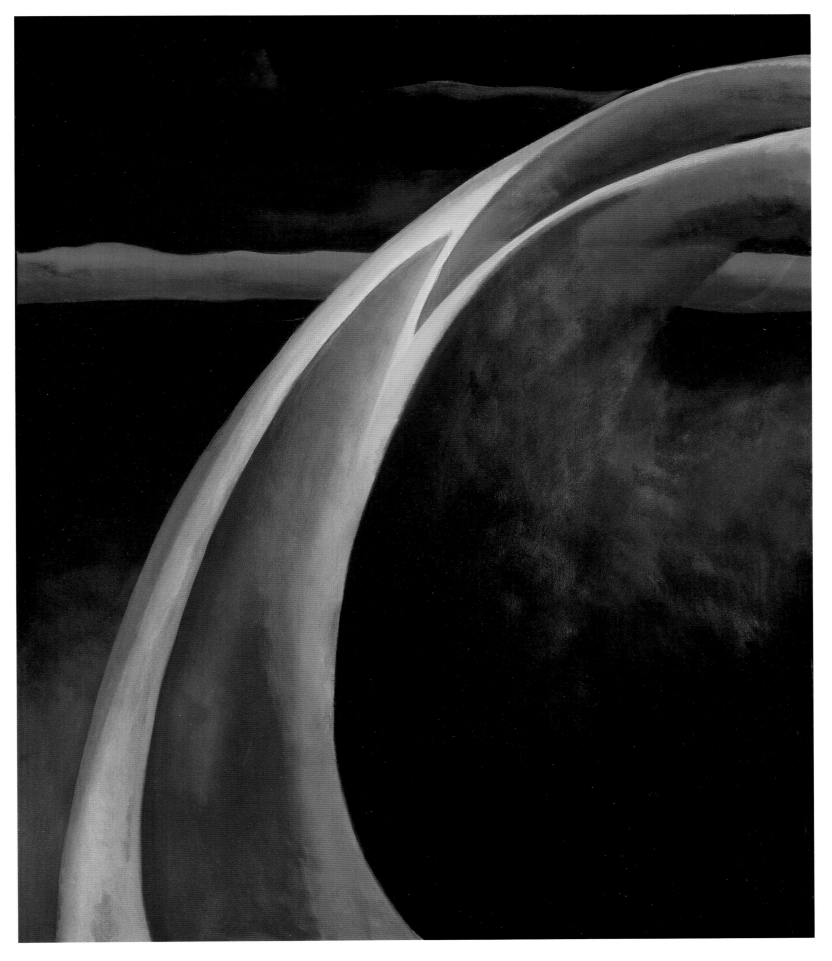

7.
Red Flower, 1919
Oil on canvas
20 ¼ x 17 ½ inches
(51.4 x 43.8 cm)
Norton Museum of Art, West
Palm Beach, Florida. Purchase,
the Esther B. O'Keeffe
Charitable Foundation, 96.5

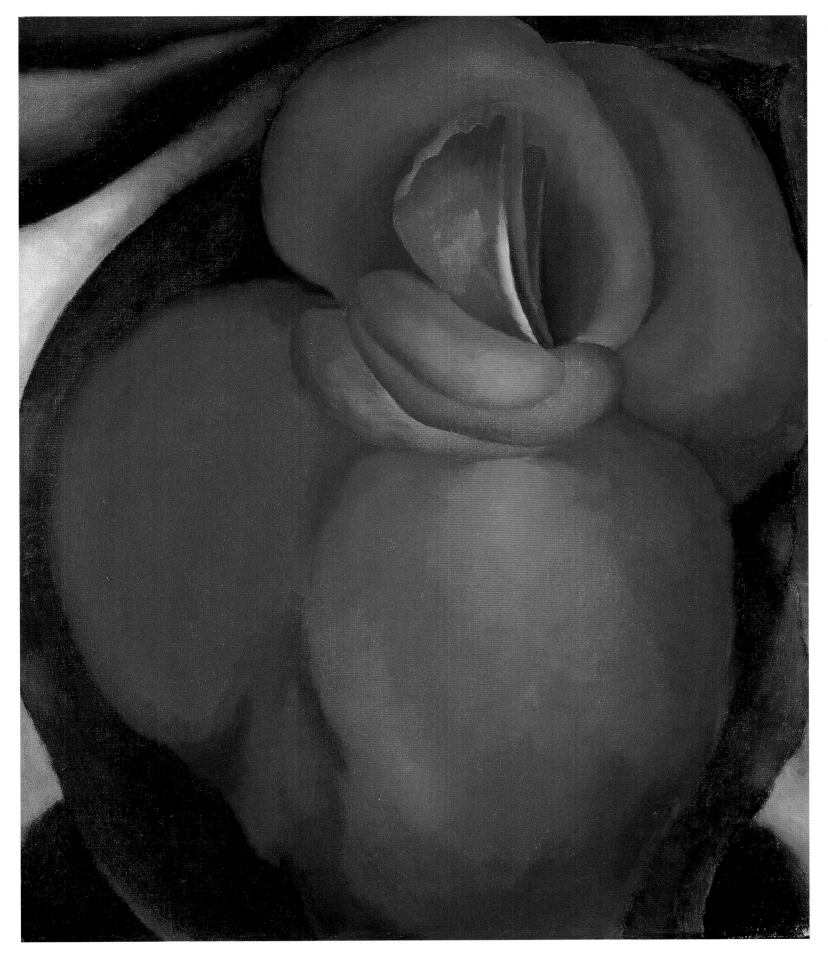

8.
*Series I, No. 8**, 1919
Oil on canvas
20 x 16 inches (50.8 x 40.6 cm)
Städtische Galerie im
Lenbachhaus, Munich

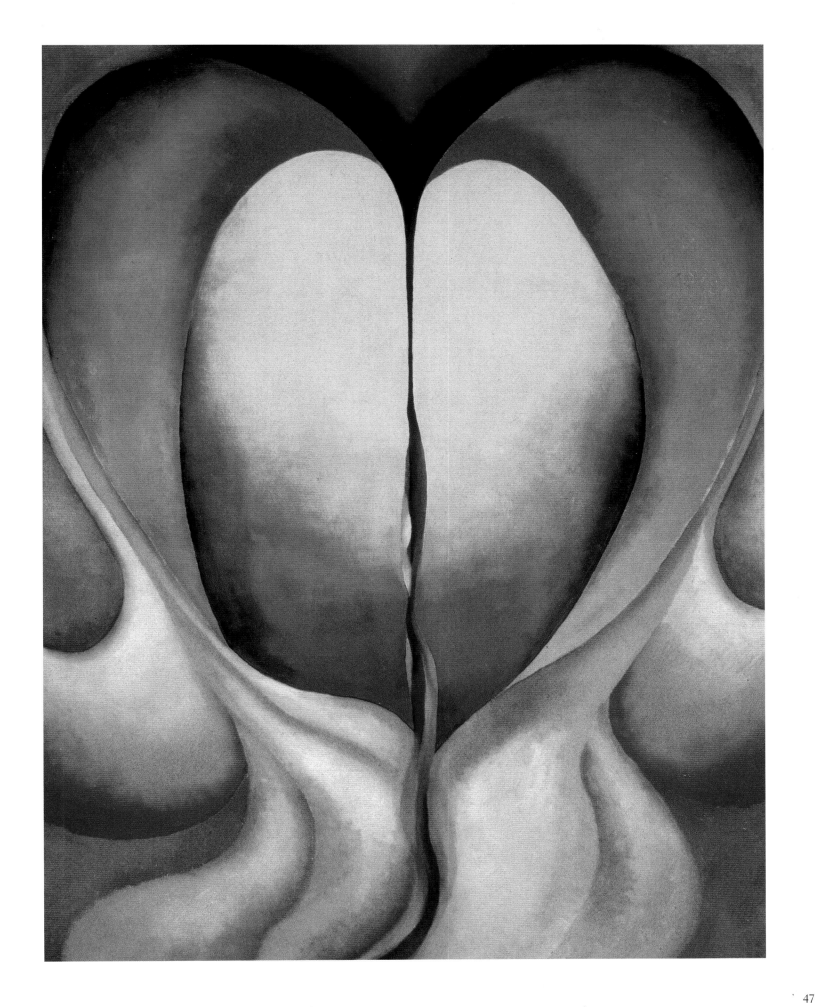

"The meaning of a word—to me—is not as exact as the meaning of a color. Color and shapes make a more definite statement than words. I write this because such odd things have been done about me with words…Where I was born and where and how I have lived is unimportant. It is what I have done with where I have been that should be of interest."

Georgia O'Keeffe, *Georgia O'Keeffe* (New York: Viking Press, 1976), p. 1

9.
*Abstraction**, 1921
Oil on canvas
25 ¼ x 20 ¼ inches
(71.1 x 61 cm)
Museo Thyssen-Bornemisza,
Madrid

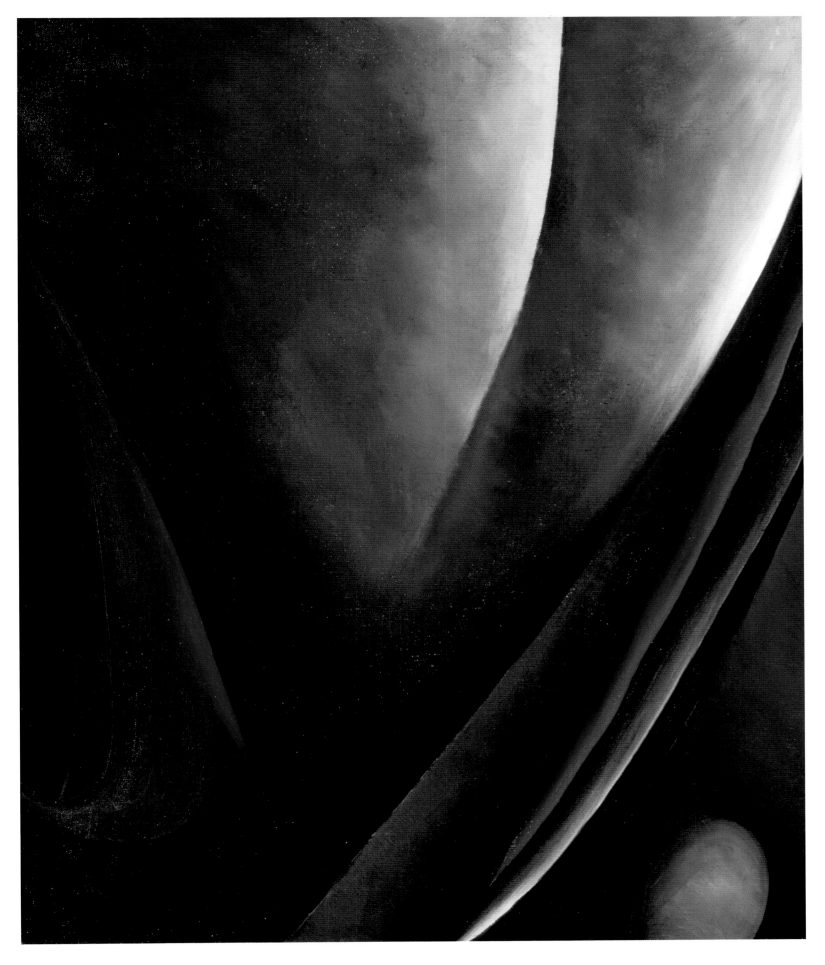

49

10.
Blue and Green Music, 1921
Oil on canvas
23 x 19 inches (58.4 x 48.3 cm)
Alfred Stieglitz Collection. Gift
of Georgia O'Keeffe, 1969.835,
The Art Institute of Chicago

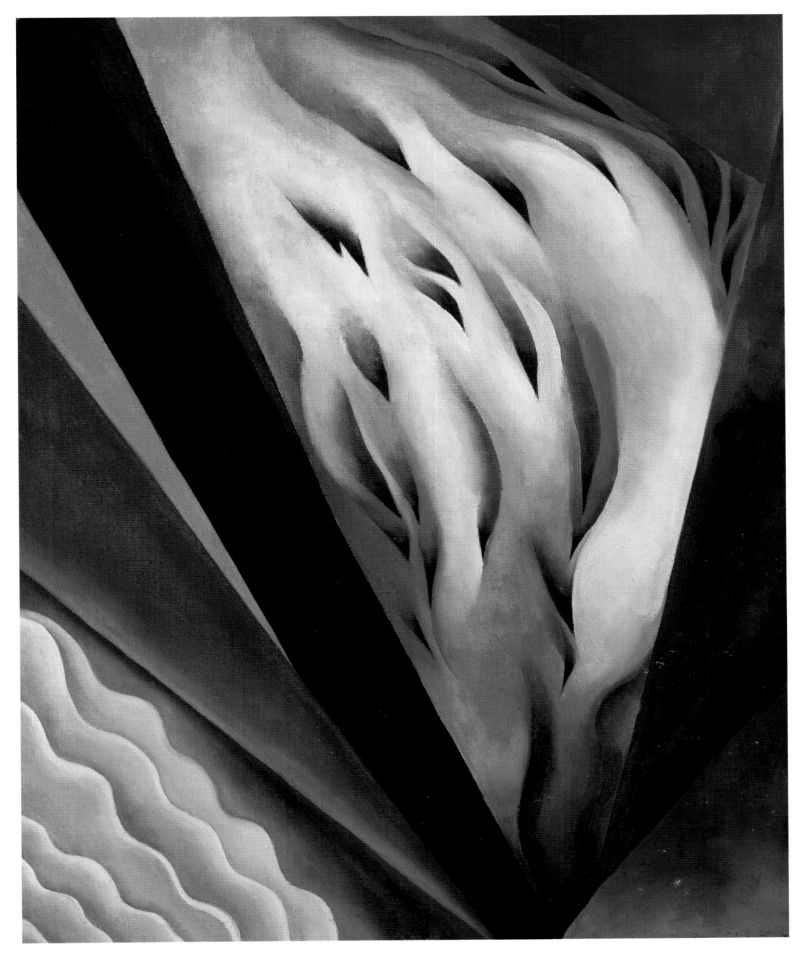

"I spent much time walking on the long, clean sandy beach—often picking up extraordinary things that I kept in large platters of water to paint. When walking I seldom met anyone as it was very early springtime and cold. I loved running down the board walk to the ocean—watching the waves come in, spreading over the hard wet beach—the lighthouse steadily bright far over the waves in the evening when it was almost dark. This was one of the great events of the day."

Georgia O'Keeffe, *Georgia O'Keeffe* (New York: Viking Press, 1976), p. 46

11.
Lake George, 1922
Oil on canvas
16 x 22 inches (40.6 x 55.9 cm)
San Francisco Museum of
Modern Art. Gift of Charlotte
Mack 52.6714

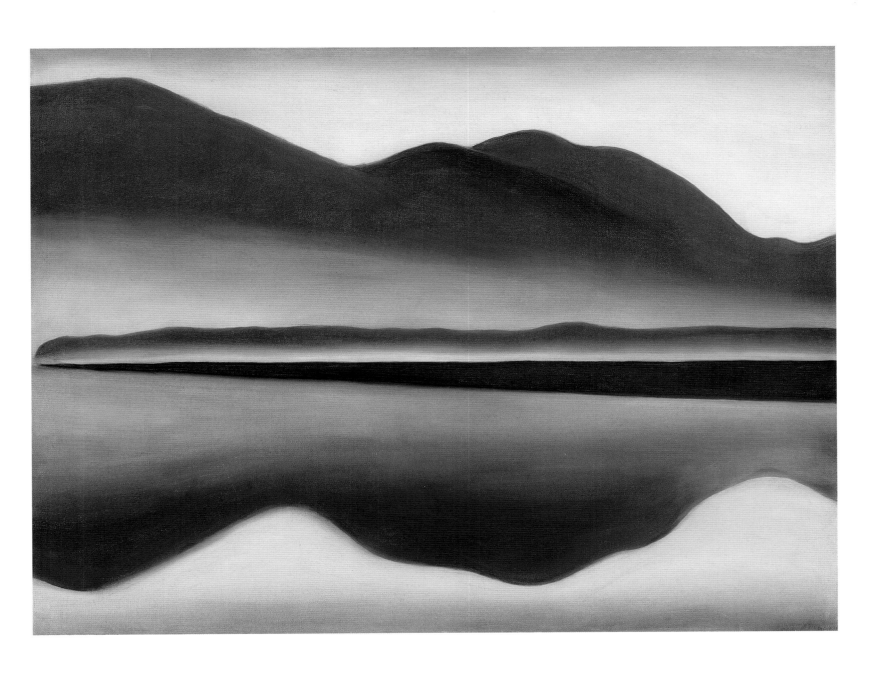

12.
*Mountains to North – Autumn –
Lake George, N.Y.*, 1922
Oil on canvas
8 x 23 inches (20.3 x 58.4 cm)
Collection of Evansville
Museum of Arts, History and
Science, Evansville, Indiana
[1966]

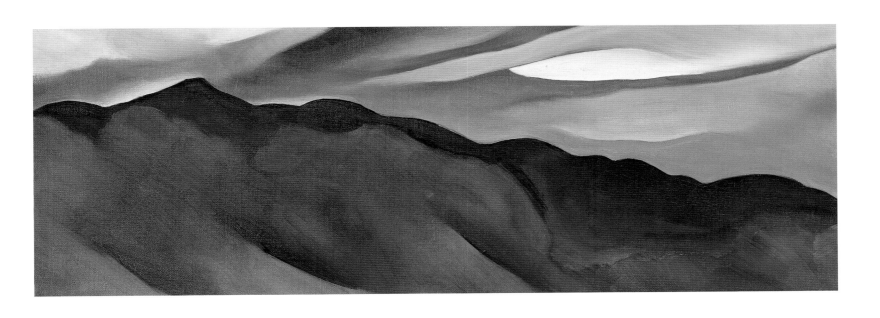

"It is surprising to me to see how many people separate the objective from the abstract. Objective painting is not good painting unless it is good in the abstract sense. A hill or tree cannot make a good painting just because it is a hill or a tree. It is lines and colors put together so that they say something. For me that is the very basis of painting. The abstraction is often the most definite form for the intangible thing in myself that I can only clarify in paint."
Georgia O'Keeffe, *Georgia O'Keeffe* (New York: Viking Press, 1976), p. 88

13.
*Spring**, c. 1922
Oil on canvas
35 1/8 x 30 3/8 inches
(89.1 x 77.1 cm)
The Frances Lehman Loeb Art Centre, Vassar College.
Bequest of Mrs. Arthur Schwab (Edna Bryner 1907)
[1967.31.15]

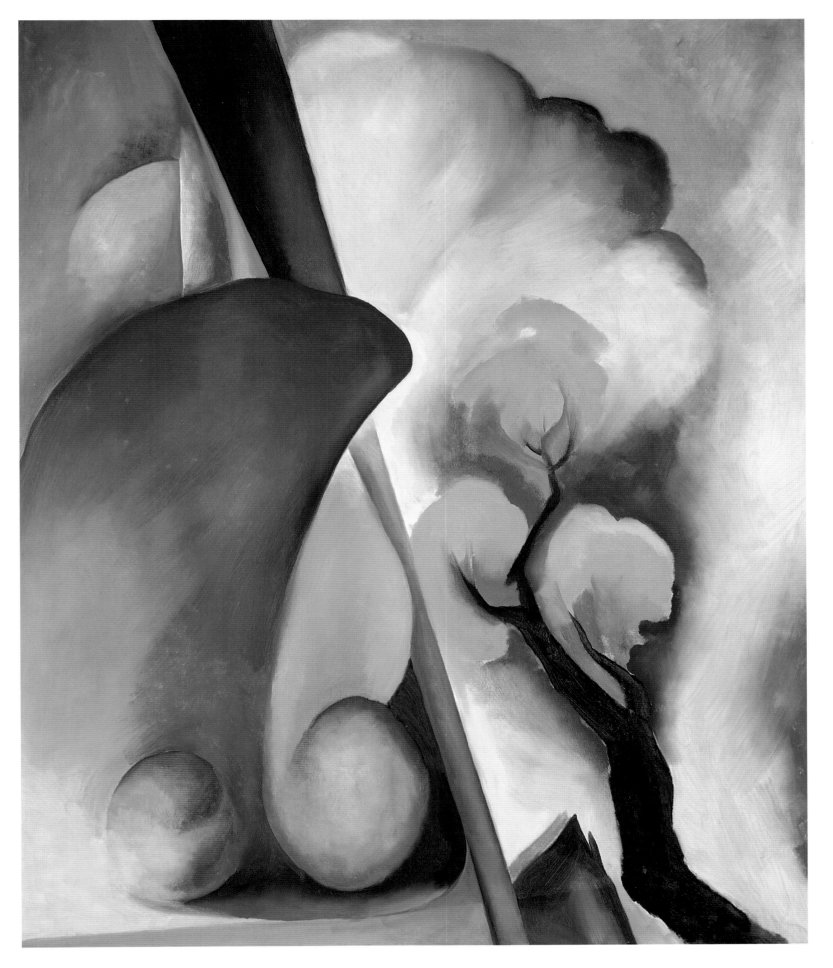

14.
*Grey Line with Lavender
and Yellow*, 1923–24
Oil on canvas
48 x 30 inches (121.9 x 76.2 cm)
The Metropolitan Museum
of Art, Alfred Stieglitz
Collection. Bequest of Georgia
O'Keeffe, 1986 (1987.377.1)

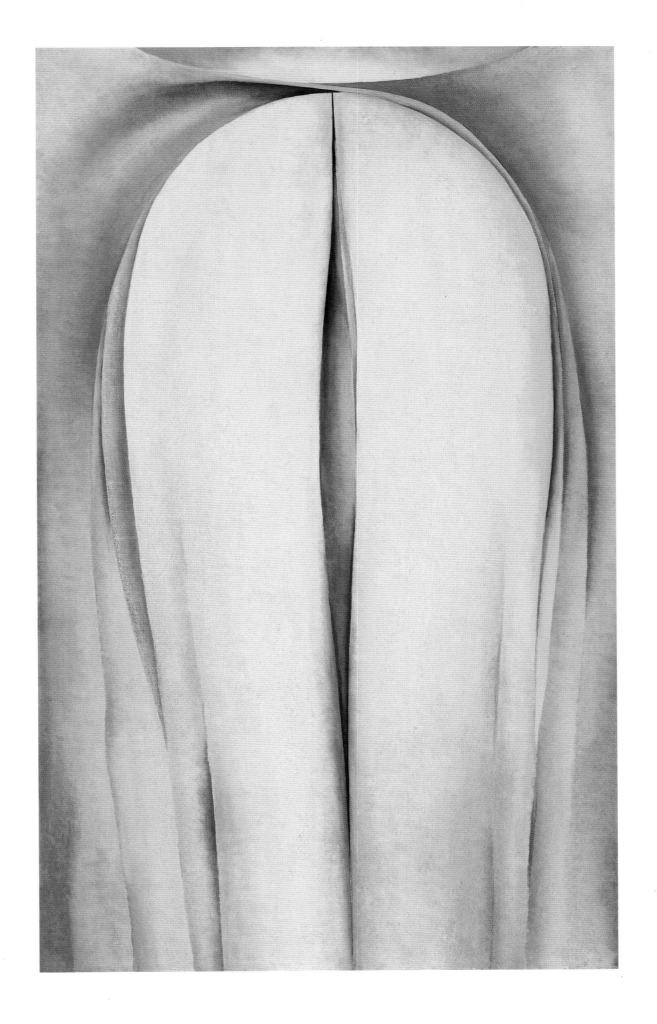

"A flower is relatively small. Everyone has many associations with a flower—the idea of flowers… Still, in a way, nobody sees a flower—really—it is so small—we haven't time—and to see takes time, like to have a friend takes time. If I could paint the flower exactly as I see it no one would see what I see because I would paint it small like the flower is small."

Georgia O'Keeffe, *Georgia O'Keeffe* (New York: Viking Press, 1976), p. 23

15.
Red Canna, c. 1925–28
Oil on canvas mounted on masonite
36 x 29 ⁷/₈ inches (91.4 x 76 cm)
Collection of The University of Arizona Museum of Art, Tucson. Gift of Oliver James

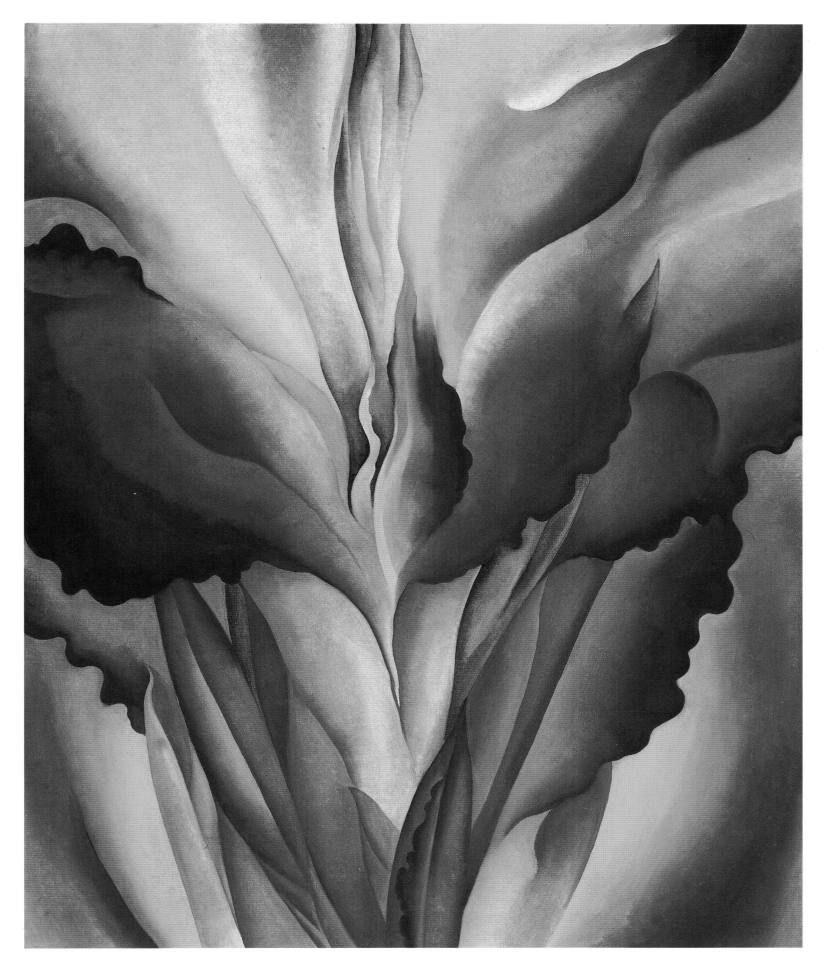

16.
Gray Line with Black, Blue and Yellow, c. 1923–25
Oil on canvas
48 x 30 inches (121.9 x 76.2 cm)
The Museum of Fine Arts, Houston; Museum purchase with funds provided by the Agnes Cullen Arnold Endowment Fund

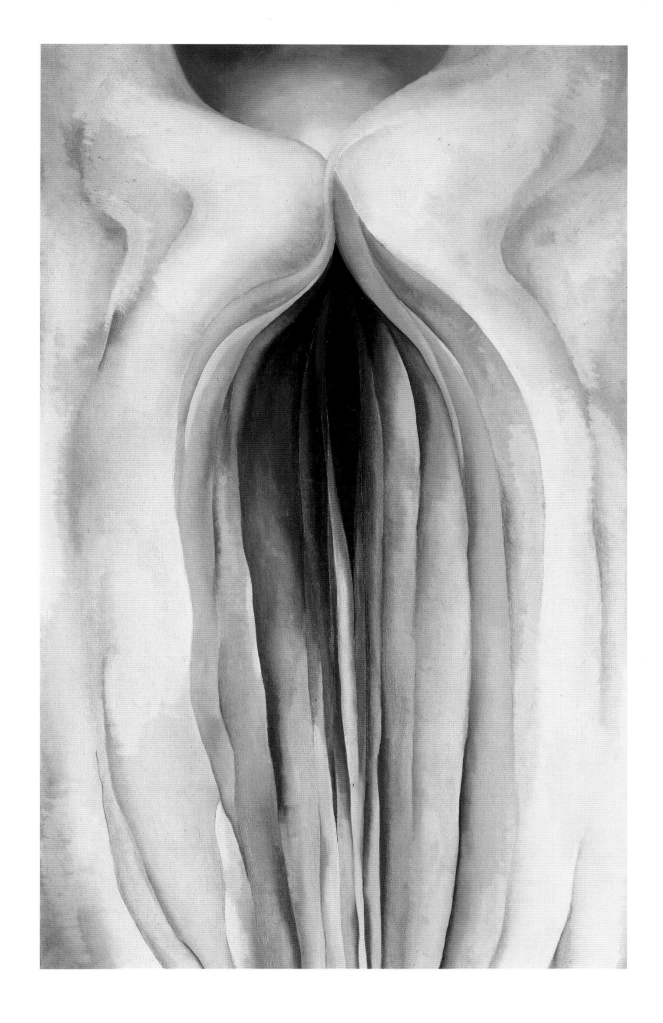

17.
A Celebration, 1924
Oil on canvas
34 7/8 x 18 inches
(88.6 x 45.7 cm)
Seattle Art Museum. Gift of the
Georgia O'Keeffe Foundation

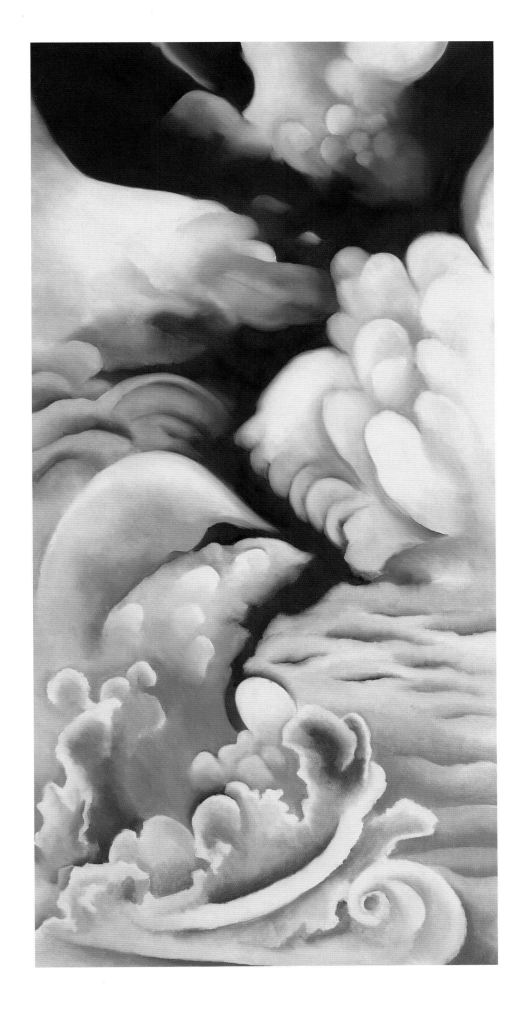

"I had a garden at Lake George for some years. The growing corn was one of my special interest—the light colored veins of the dark green leaves reaching out in opposite directions. And every morning a little drop of dew would have run down the veins into the center of this plant like a little lake—all fine and fresh."
Georgia O'Keeffe, *Georgia O'Keeffe* (New York: Viking Press, 1976), p. 34

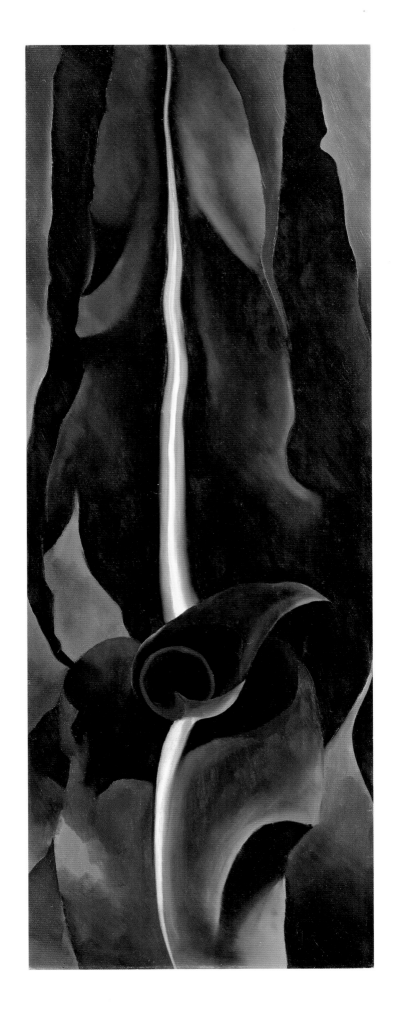

19.

Corn, No. 2, 1924
Oil on canvas
27 1/4 x 10 inches
(69.1 x 25.5 cm)
Santa Fe, The Georgia O'Keeffe
Museum

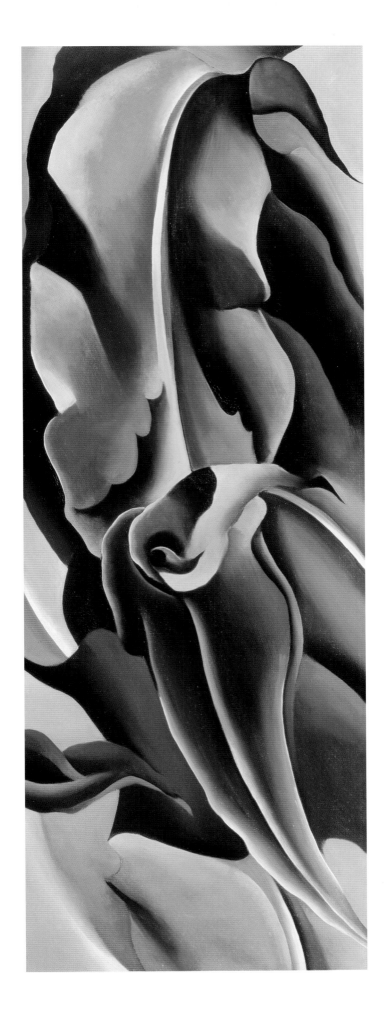

*"The unexplainable thing in nature that makes me feel
the world is big far beyond my understanding—to understand
maybe by trying to put it into form. To find the feeling of infinity
on the horizon line or just over the next hill."*
Georgia O'Keeffe, *Georgia O'Keeffe* (New York: Viking
Press, 1976), p. 100

20.
Dark Abstraction, 1924
Oil on canvas
25 3/8 x 21 1/8 (64.5 x 53.7 cm)
Saint Louis Art Museum. Gift
of Charles E. and Mary Merrill

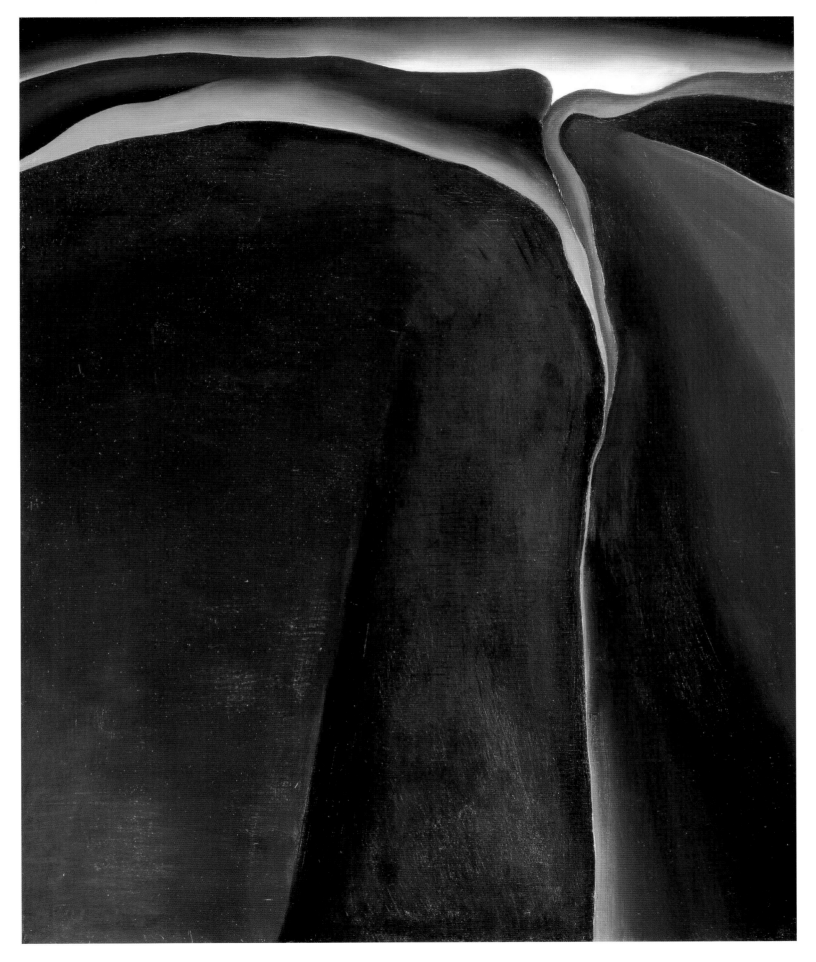

21.
*Flower Abstraction**, 1924
Oil on canvas
48 x 30 inches (121.9 x 76.2 cm)
Whitney Museum of American
Art, New York. 50th
Anniversary Gift of Sandra
Payson 85.47

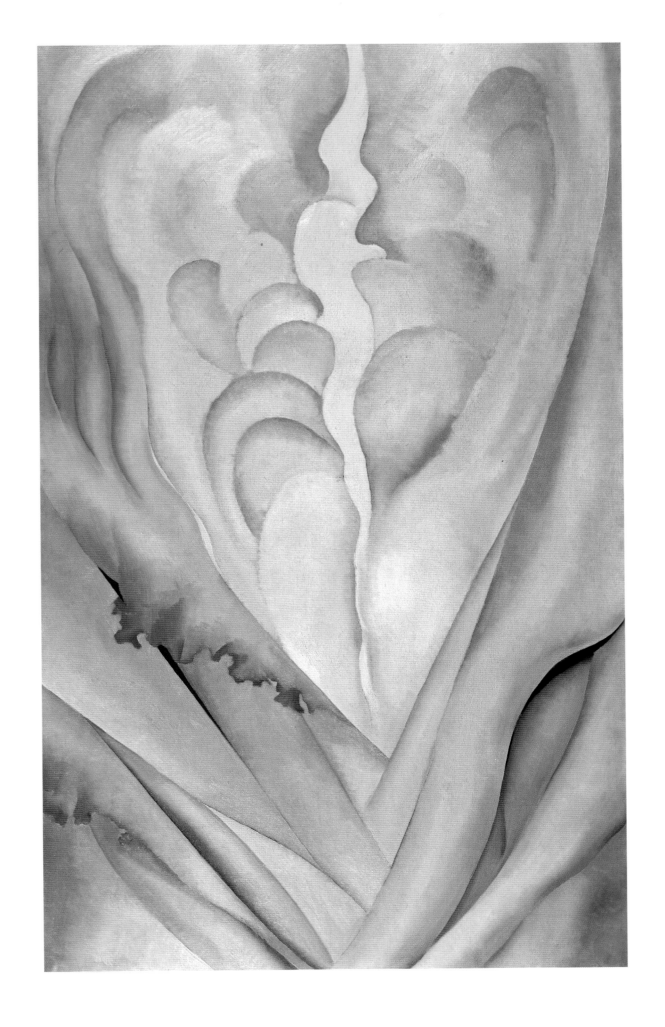

22.
From the Lake, No. I, 1924
Oil on canvas
30 x 36 inches (76.2 x 91.4 cm)
Purchased with funds from the
Coffin Fine Arts Trust; Nathan
Emory Coffin Collection of the
Des Moines Art Center, 1984.3

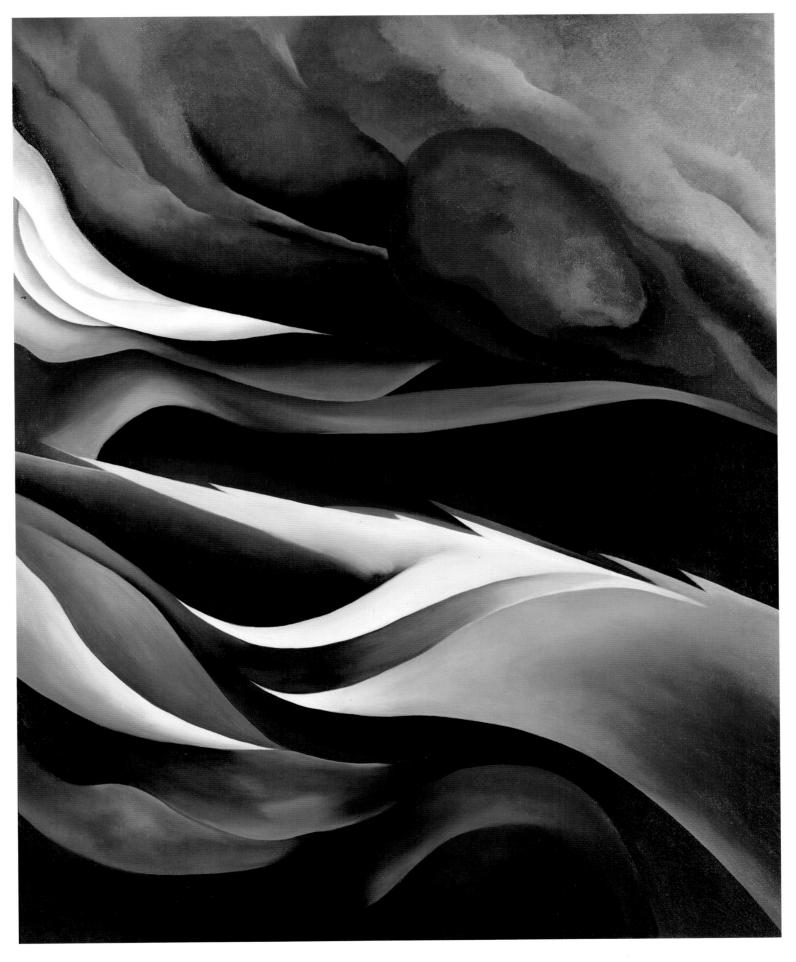

23.
Leaf Motif, No. 1, 1924
Oil on canvas
32 x 18 inches (81.2 x 45.7 cm)
Private collection, Switzerland

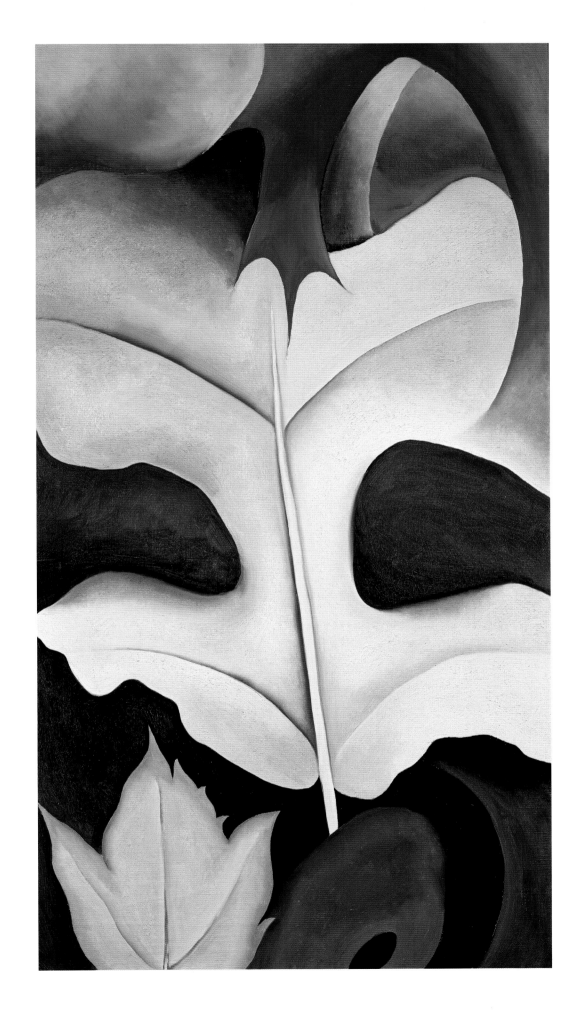

24.
Leaf Motif, No. 2, 1924
Oil on canvas
35 x 18 inches (90.6 x 45.7 cm)
Collection of the McNay Art
Museum, Mary and Sylvan
Lang Collection

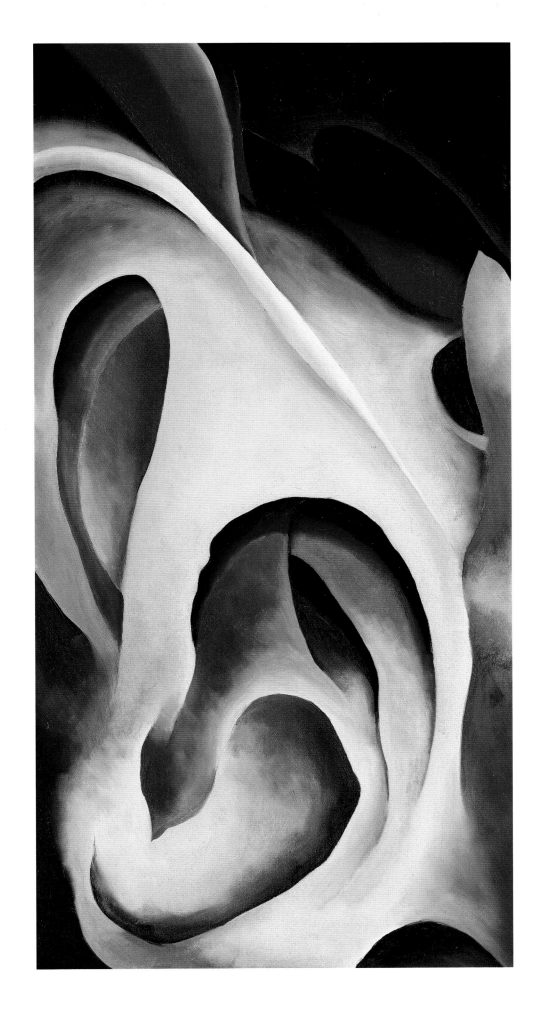

25.
Red, Yellow and Black Streak,
1924
Oil on canvas
39 ³/₈ x 31 ³/₄ inches
(101,3 x 81,3 cm)
Paris, Musée national d'Art
moderne, Centre Georges
Pompidou. Don de la Georgia
O'Keeffe Foundation 1995,
inv.: AM 1995-178

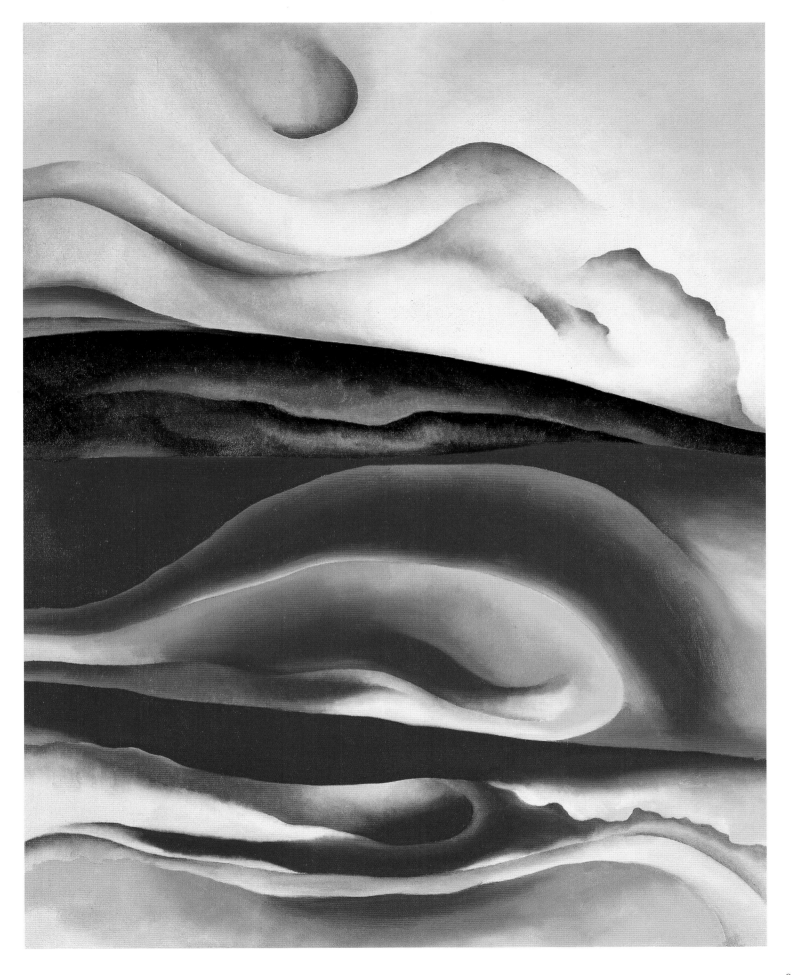

"A little way from the dock there was a big old birch tree with many trunks. I have painted the foliage green and have painted it yellow many times. To see the tree at its best I was up early and out in the rowboat under the trees as the sun came up over the mountains across the lake. The trunks were whitest in the early sunrise—the foliage a golden yellow with a few leaves standing out sharply here and there." Georgia O'Keeffe, *Georgia O'Keeffe* (New York: Viking Press, 1976), p. 43

26.
*Birch Trees**, 1925
Oil on canvas
36 x 30 inches (91.4 x 76.2 cm)
Saint Louis Art Museum. Gift of
Mrs. Ernest W. Stix

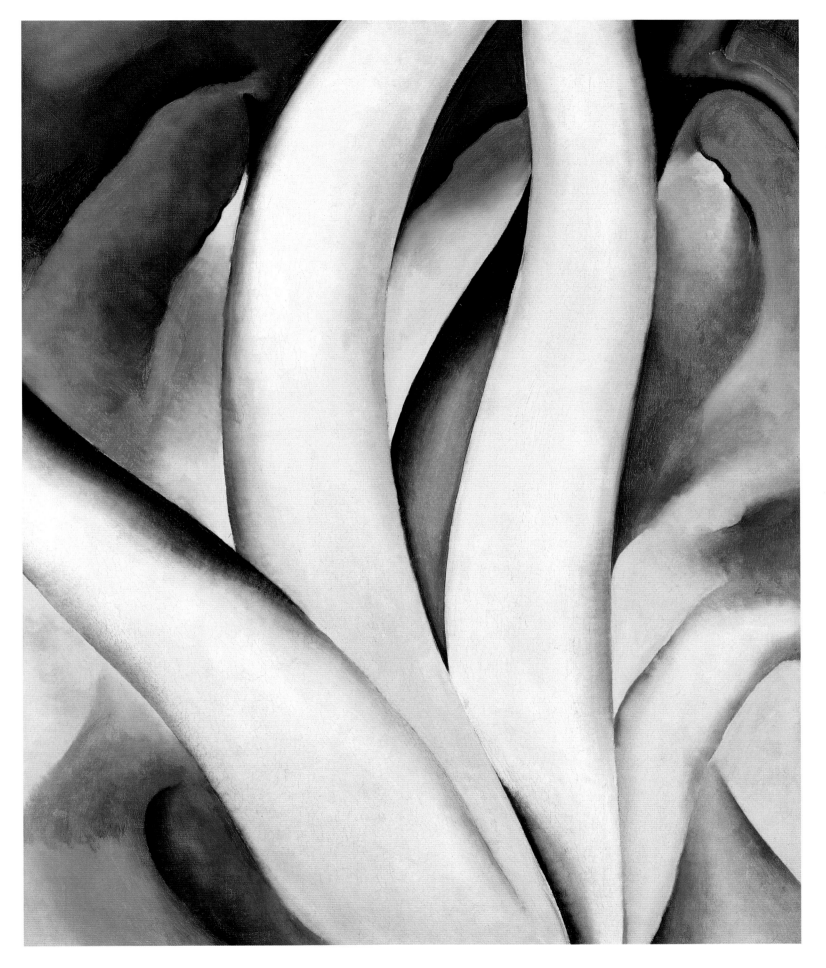

"There are people who have made me see shapes—and others
I thought of a great deal, even people I have loved, who make me see
nothing… I remember hesitating to show the paintings, they looked
so real to me. But they have passed into the world as abstractions—no
one seeing what they are."
Georgia O'Keeffe, *Georgia O'Keeffe* (New York: Viking Press,
1976), p. 55

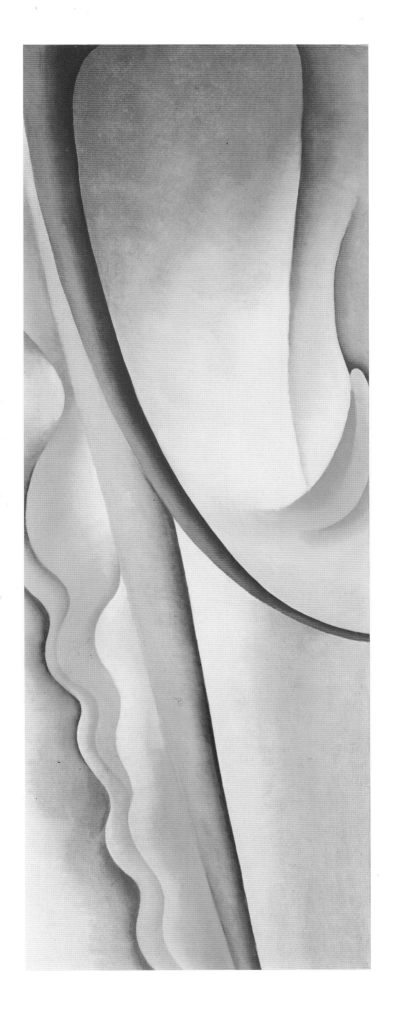

"So I said to myself—I'll paint what I see—what the flower is to me but I'll paint it big and they will be surprised into taking time to look at it—I will make even busy New Yorkers take time to see what I see of flowers."
Georgia O'Keeffe, *Georgia O'Keeffe* (New York: Viking Press, 1976), p. 23

28.
*Purple Petunias**, 1925
Oil on canvas
15 7/8 x 13 inches (40 x 33 cm)
Collection of The Newark
Museum. Bequest of Miss Cora
Louise Hartshorn, 1958.
Inv. 58.167

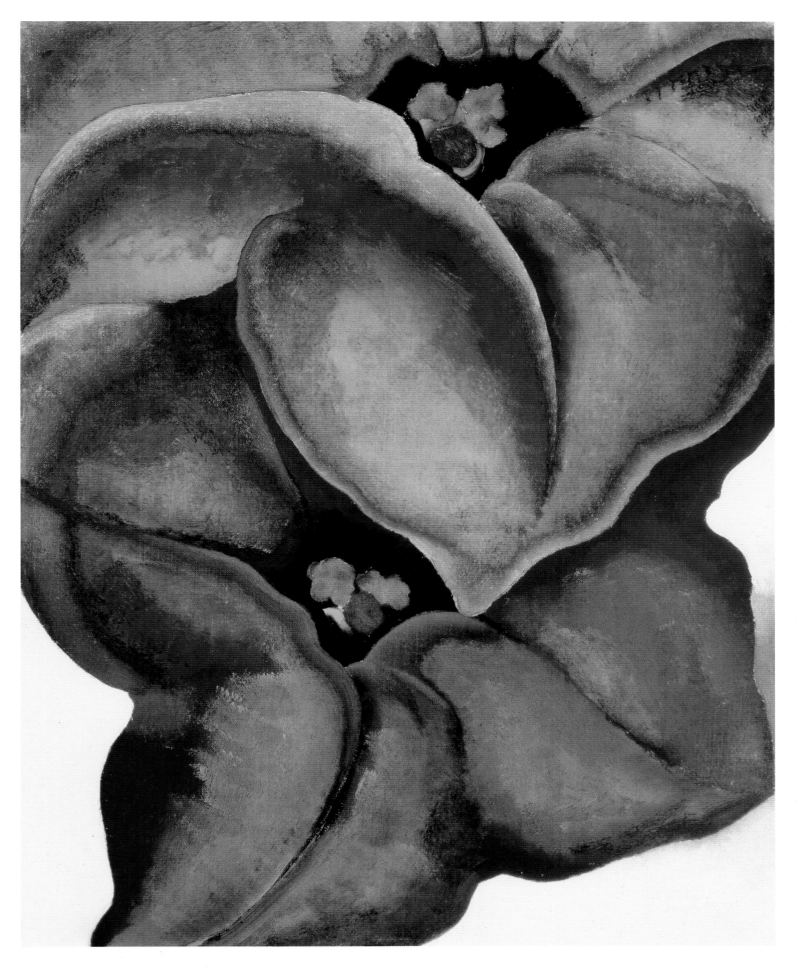

29.
*Abstraction**, 1926
Oil on canvas
30 ¹/₄ x 18 inches
(76.8 x 45.7 cm)
Whitney Museum of American
Art, New York. Purchase 58.43

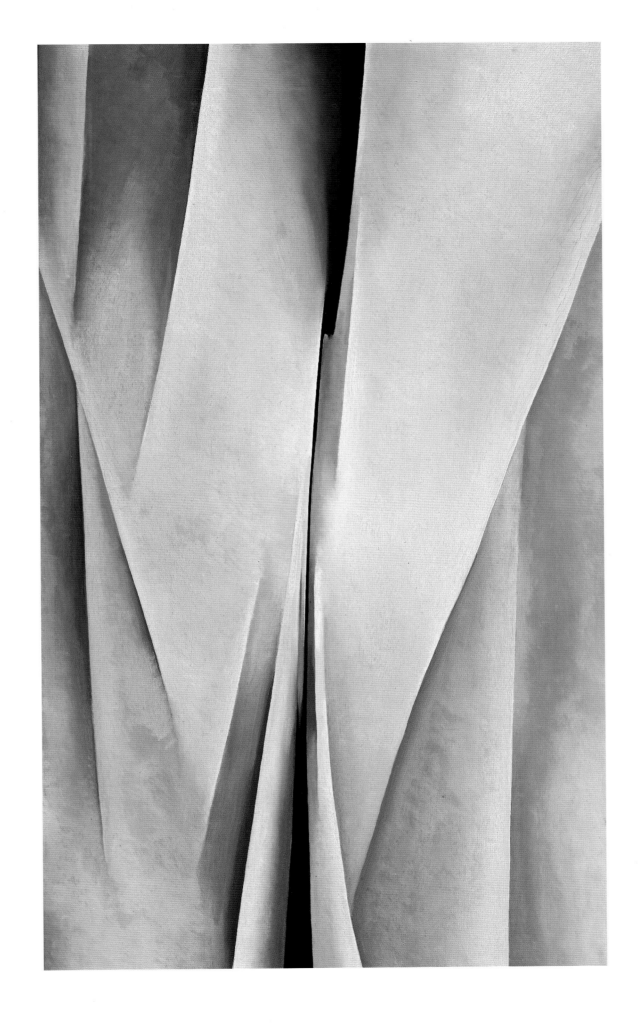

30.
Black Iris, 1926
Oil on canvas
36 x 29 $^7/_8$ inches
(91.4 x 75.9 cm)
The Metropolitan Museum
of Art, Alfred Stieglitz
Collection, 1969 (69.278.1)

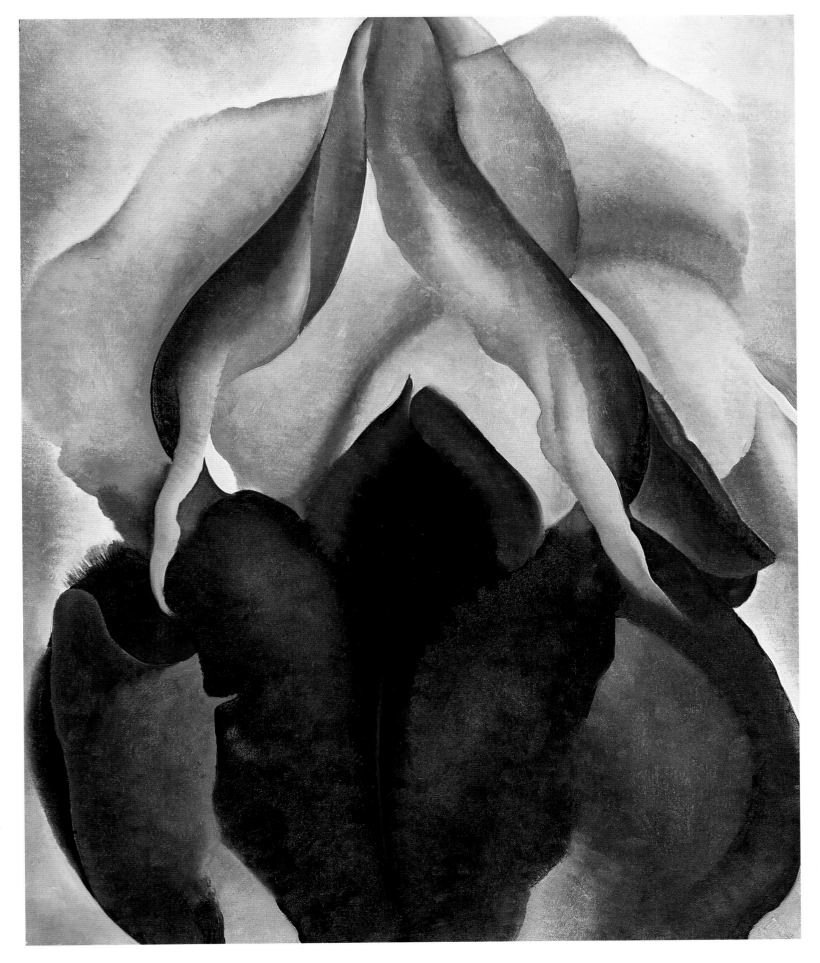

*"I'll tell you how I happened to make the blown-up flowers.
In the twenties, huge buildings sometimes seemed to be going up
overnight in New York. At that time I saw a painting by Fantin-
Latour, a still-life with flowers I found very beautiful, but I realized
that were I to paint the same flowers so small, no one would look
at them because I was unknown. So I thought I'll make them
big like the huge buildings going up. People will be startled; they'll
have to look at them——and they did."*
Georgia O'Keeffe interviewed by Katherine Kuh in *The Artist's
Voice*, 1960

31.
Canna, Red and Orange, 1926
Oil on canvas
20 x 16 inches (50.8 x 40.6 cm)
Santa Fe, The Georgia O'Keeffe
Museum

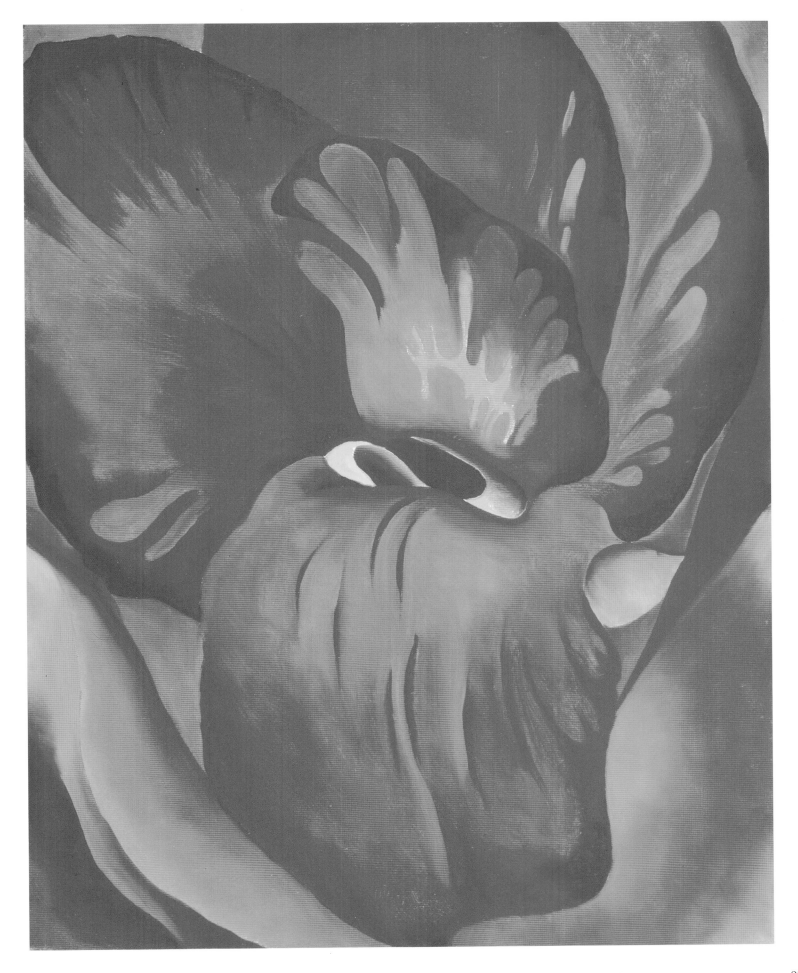

32.
Pink Tulip, 1926
Oil on canvas
36 x 30 inches (91.4 x 76.2 cm)
The Baltimore Museum of Art.
Bequest of Mabel Garrison
BMA 1964.11.13

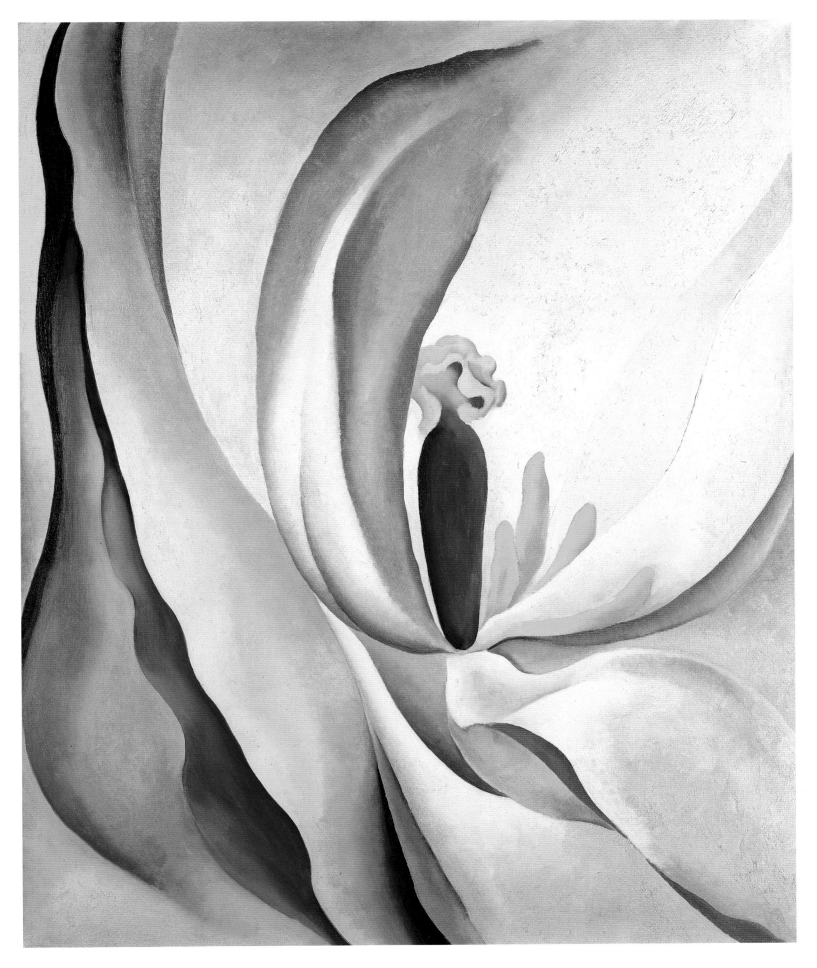

"I said to myself, 'I have things in my head that are not like what anyone has taught me—shapes and ideas so near to me—so natural to my way of being and thinking that it hasn't occurred to me to put them down.' I decided to start anew—to strip away what I had been taught—to accept as true my own thinking."
Georgia O'Keeffe, *Georgia O'Keeffe* (New York: Viking Press, 1976), n.p.

33.
*Abstraction Blue**, 1927
Oil on canvas
40 ¹/₄ x 30 inches
(102.1 x 76.2 cm)
New York, Museum of Modern
Art (MoMA). Acquired through
the Helen Acheson Bequest.
Acc. no.:71.1979

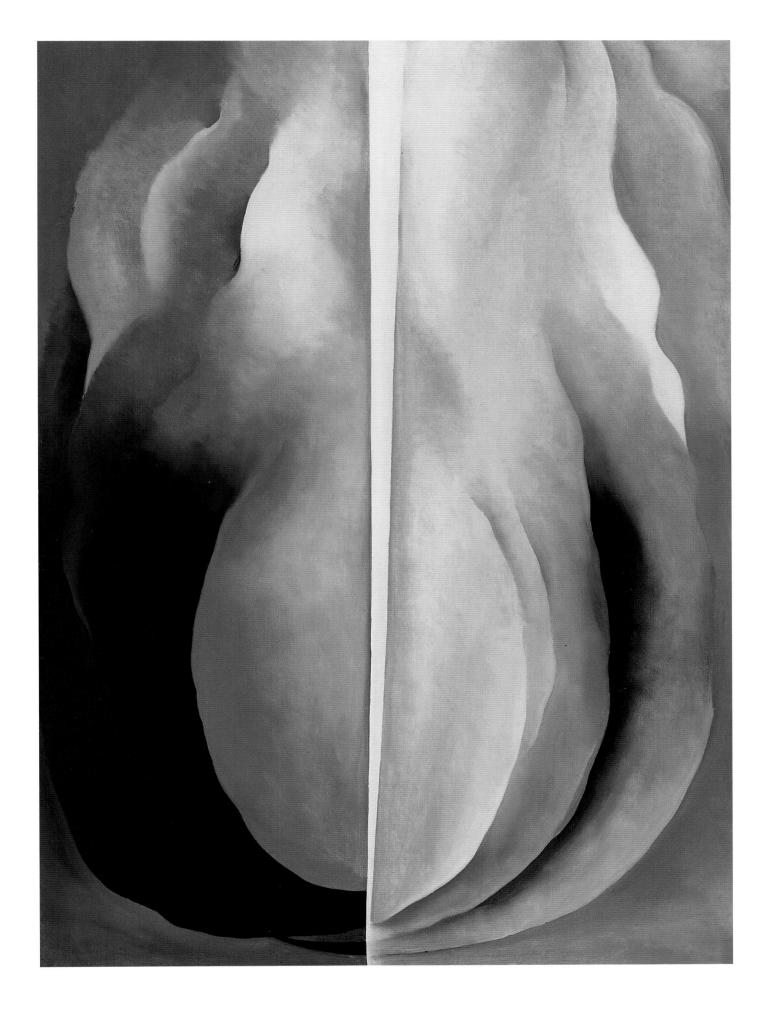

34.
Abstraction White Rose, 1927
Oil on canvas
36 x 30 inches (91.4 x 76.2 cm)
Santa Fe, The Georgia O'Keeffe
Museum

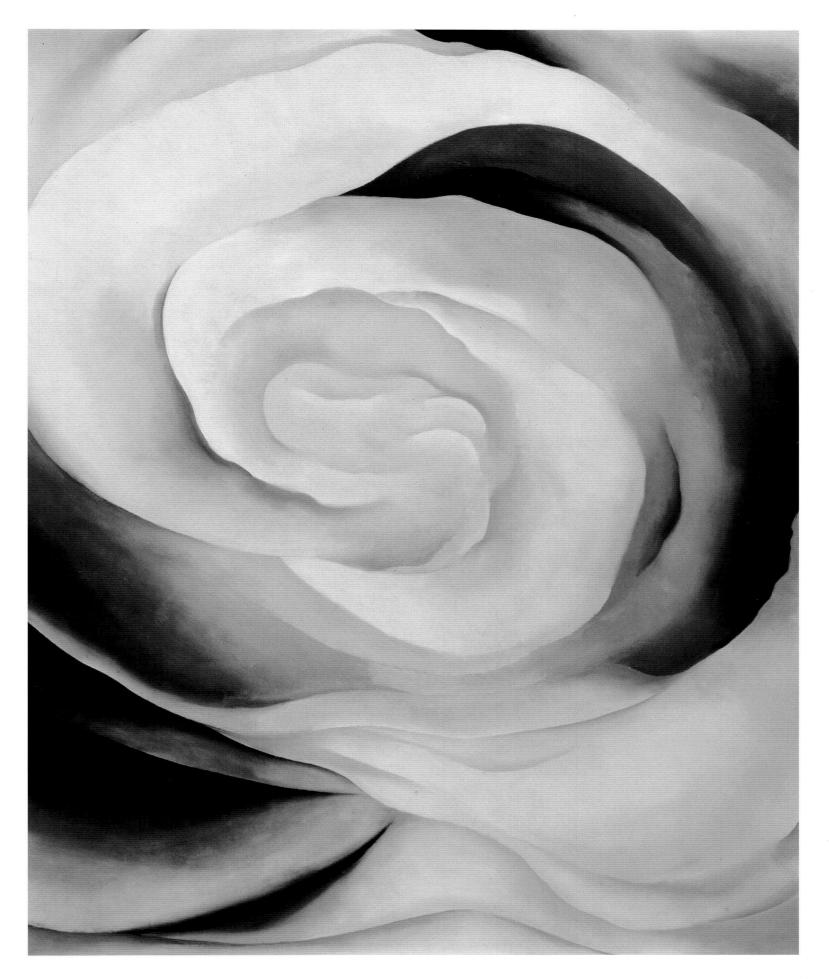

35.
Ballet Skirt or *Electric Light*,
1927
Oil on canvas
36 x 30 inches (91.4 x 76.2 cm)
Alfred Stieglitz Collection.
Bequest of Georgia O'Keeffe,
1987.250.1, The Art Institute of
Chicago

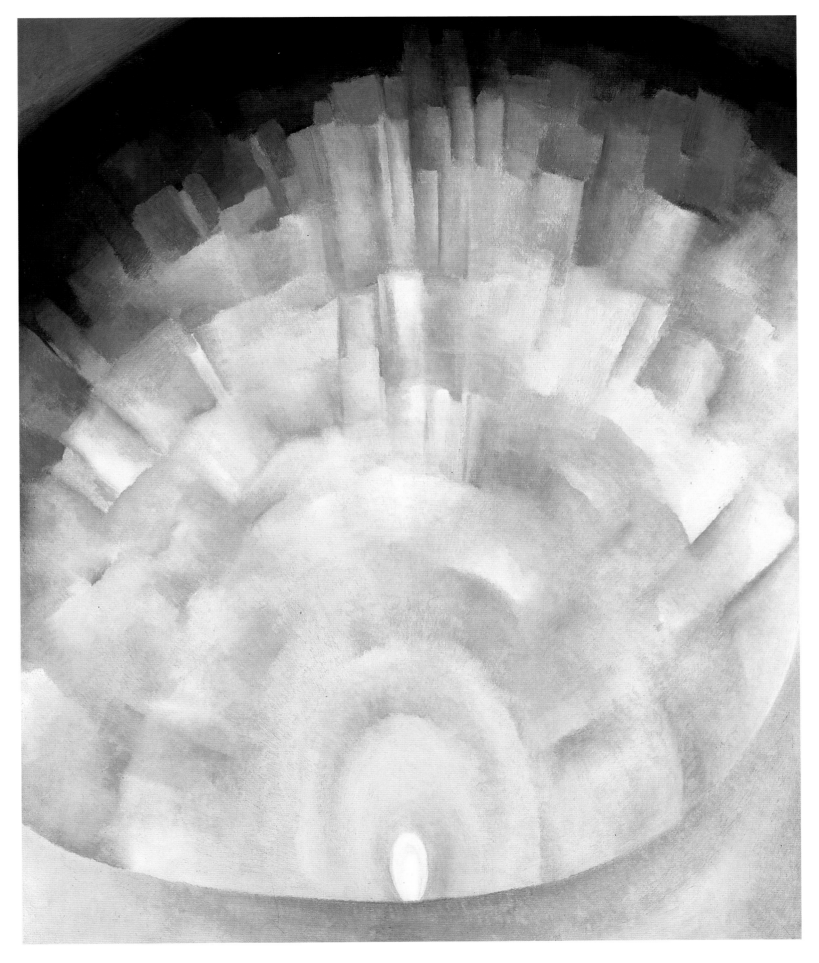

"I can see shapes… it's as if my mind creates shapes that I don't know about. I get this shape in my head… sometimes I know what it comes from and sometimes I don't."
O'Keeffe in documentary *Georgia O'Keeffe* (dir. Peter Miller Adato, WNET/13, 1977)

36.
Black Abstraction, 1927
Oil on canvas
30 x 40 ¼ inches
(76.2 x 102.2 cm)
The Metropolitan Museum of Art, Alfred Stieglitz Collection, 1969 (69.278.2)

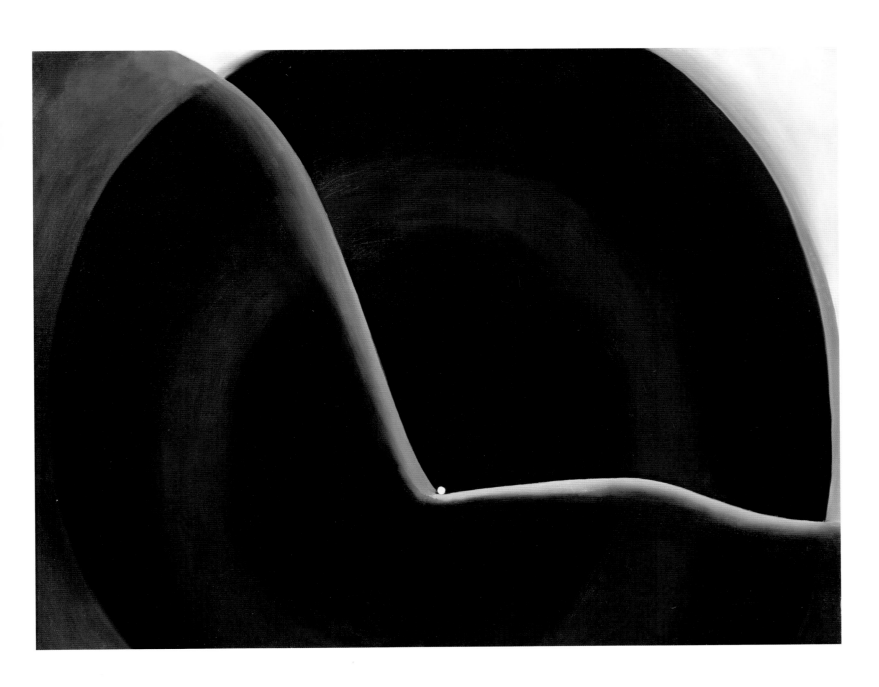

37.
Red Cannas, 1927
Oil on canvas
36 $\frac{1}{8}$ x 30 $\frac{1}{8}$ inches
(91.7 x 76.5 cm)
Amon Carter Museum,
Fort Worth, Texas
Georgia O'Keeffe 1986.11

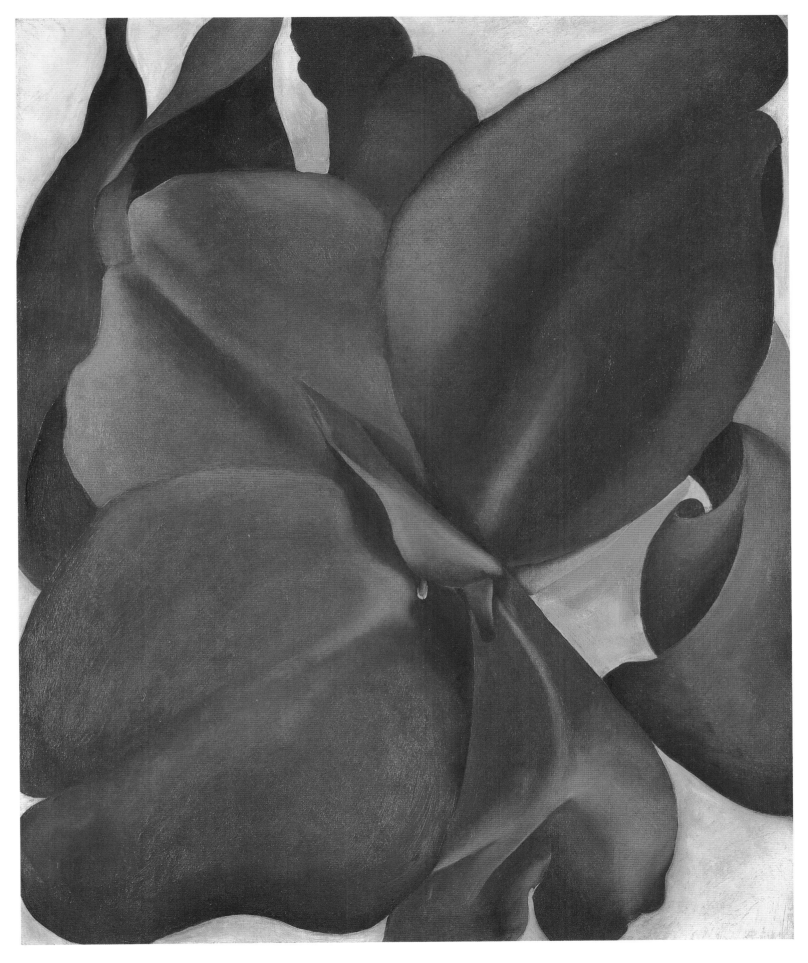

38.

Wave, Night, 1928
Oil on canvas
30 x 36 ¹/₄ inches
(76.2 x 91.4 cm)
Addison Gallery of American
Art, Phillips Academy, Andover,
Massachusetts. All Rights
Reserved. Purchased as the gift
of Charles L. Stillman (PA 1922)

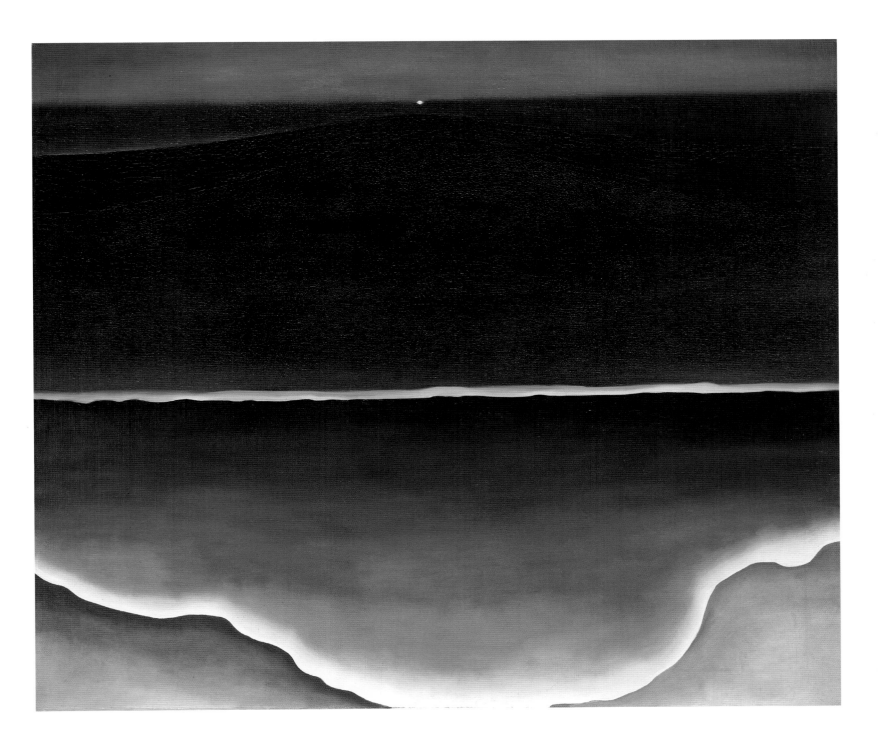

39.

Grey Blue & Black – Pink Circle,
1929
Oil on canvas
36 x 48 inches (91.4 x 121.9 cm)
Dallas Museum of Art. Gift
of The Georgia O'Keeffe
Foundation

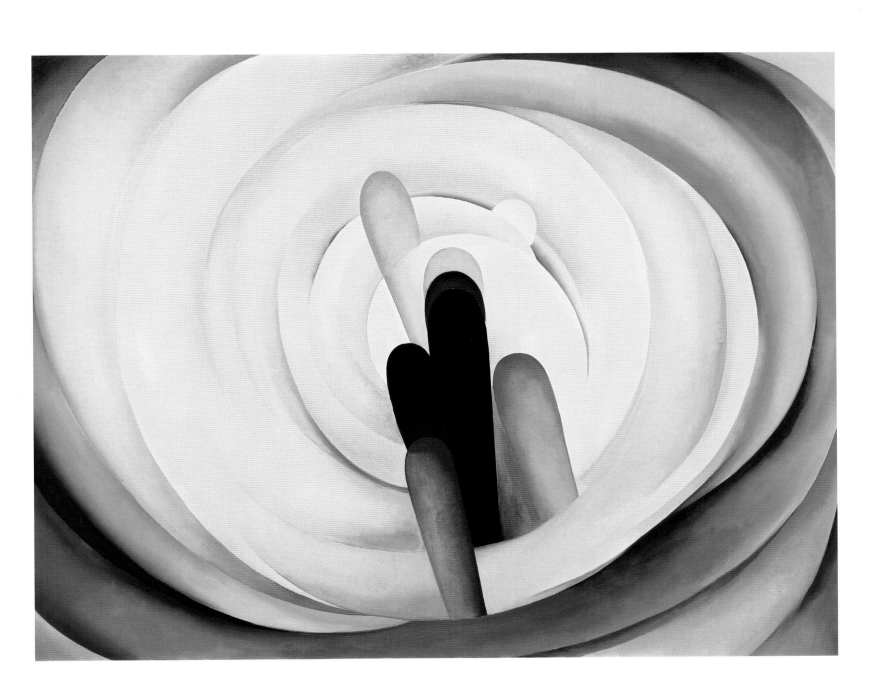

40.
*White Flower**, 1932
Oil on canvas
16 x 20 inches (40.6 x 50.8 cm)
Muscarelle Museum of Art,
College of William and Mary.
Gift of Mrs. John D.
Rockefeller, Jr.

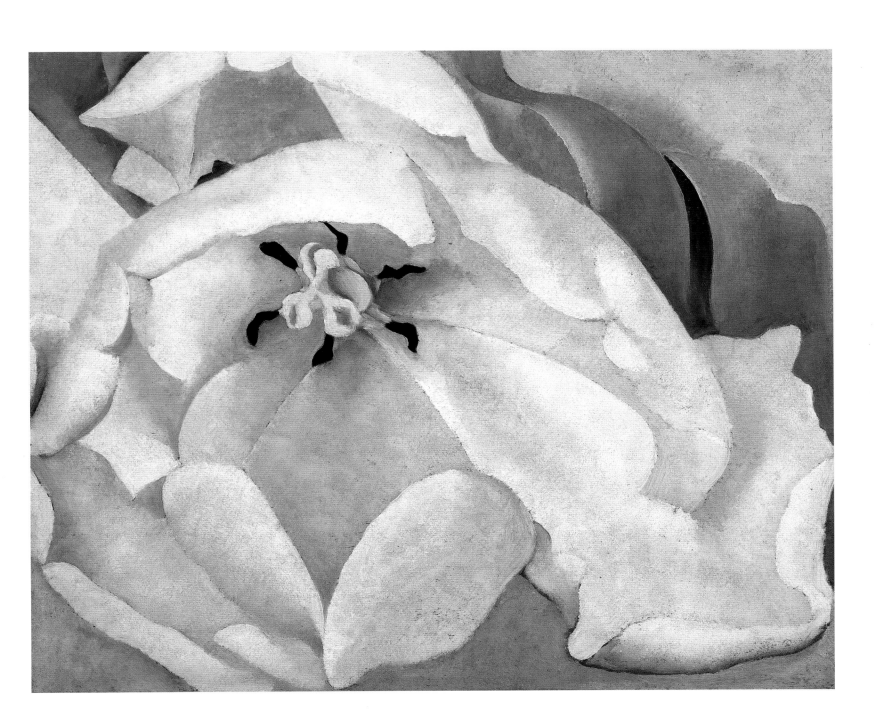

41.
*2 Yellow Leaves**, 1928
Oil on canvas
40 x 30 inches (101.6 x 76.2 cm)
Brooklyn Museum. 87.136.6.
Bequest of Georgia O'Keeffe

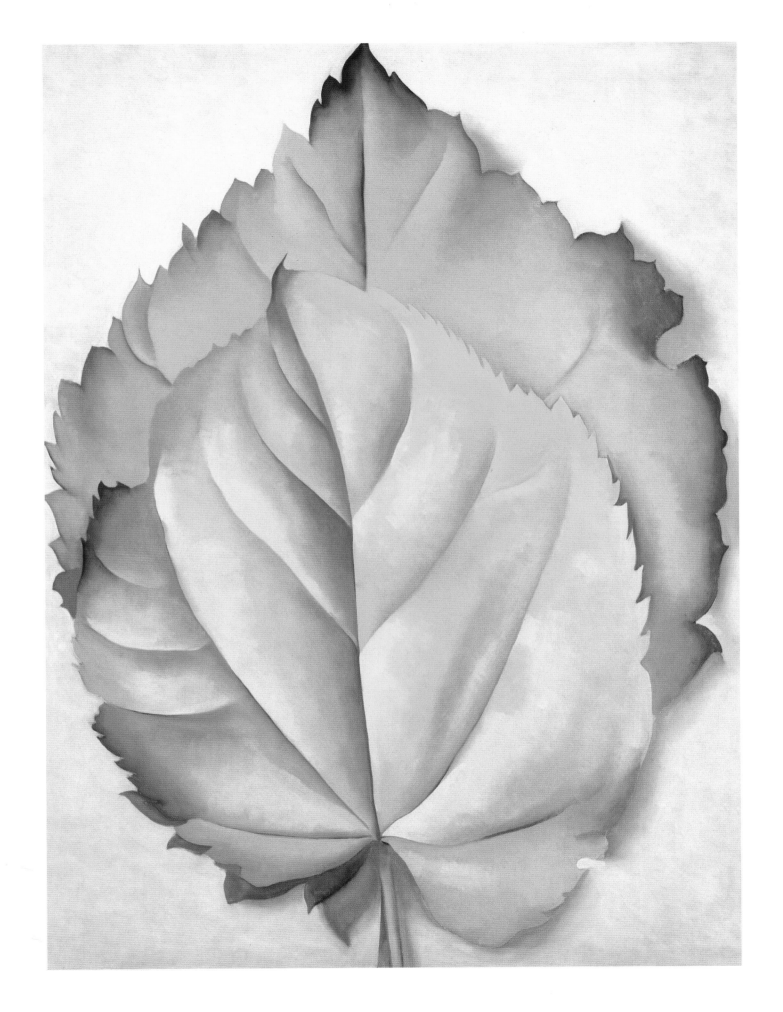

42.
*Oak Leaves, Pink and Grey**,
1929
Oil on canvas
33 1/8 x 18 inches
(84.1 x 45.7 cm)
Weisman Art Museum,
University of Minnesota

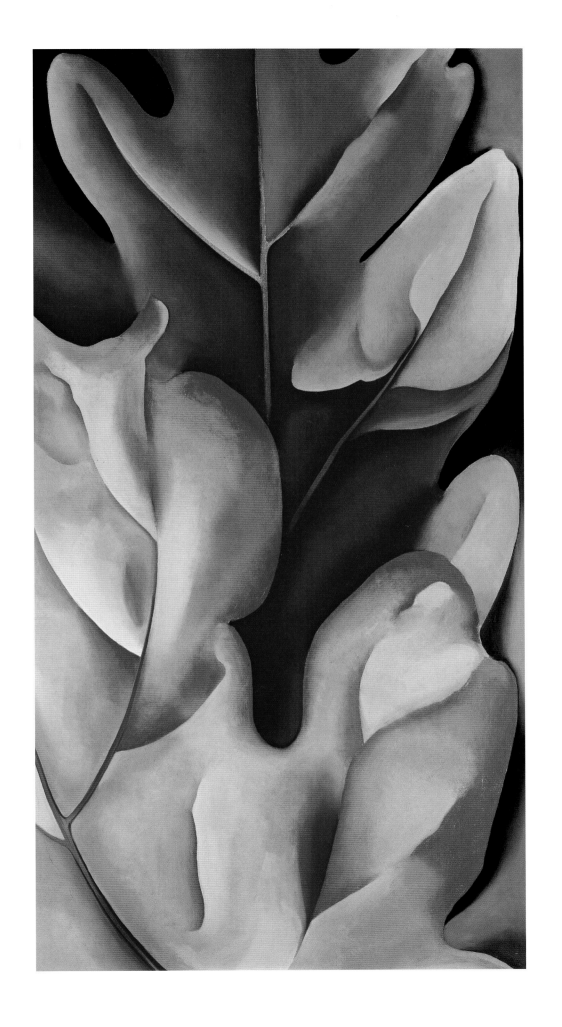

*"The summer of 1929 when I was at Mabel's in Taos, I had the
house that D. H. Lawrence had the summer before he went to Italy...
I spent several weeks up at the Lawrence ranch that summer.
There was a long weathered carpenter's bench under the tall tree
in front of the little old house that Lawrence had lived in there.
I often lay on that bench looking up into the tree—past the trunk
into the branches. It was particularly fine at night with the stars
above the tree."*
Georgia O'Keeffe, *Georgia O'Keeffe* (New York: Viking Press,
1976), p. 57

43.
D. H. Lawrence Pine Tree, 1929
Oil on canvas
31 ⅛ x 39 ¼ inches
(79 x 99.6 cm)
Wadsworth Atheneum
Museum of Art, Hartford, CT.
The Ella Gallup Sumner and
Mary Catlin Sumner Collection
Fund

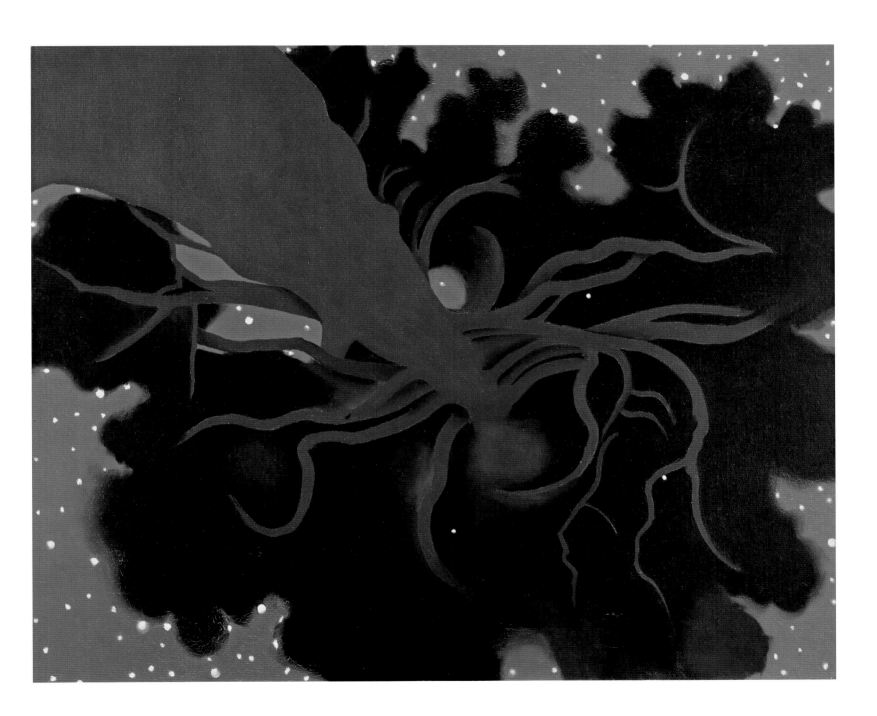

44.
Black White and Blue, 1930
Oil on canvas
48 x 30 inches
(121.9 x 76.2 cm)
National Gallery of Art,
Washington. Gift (Partial and
Promised) Collection of Barney
A. Ebsworth

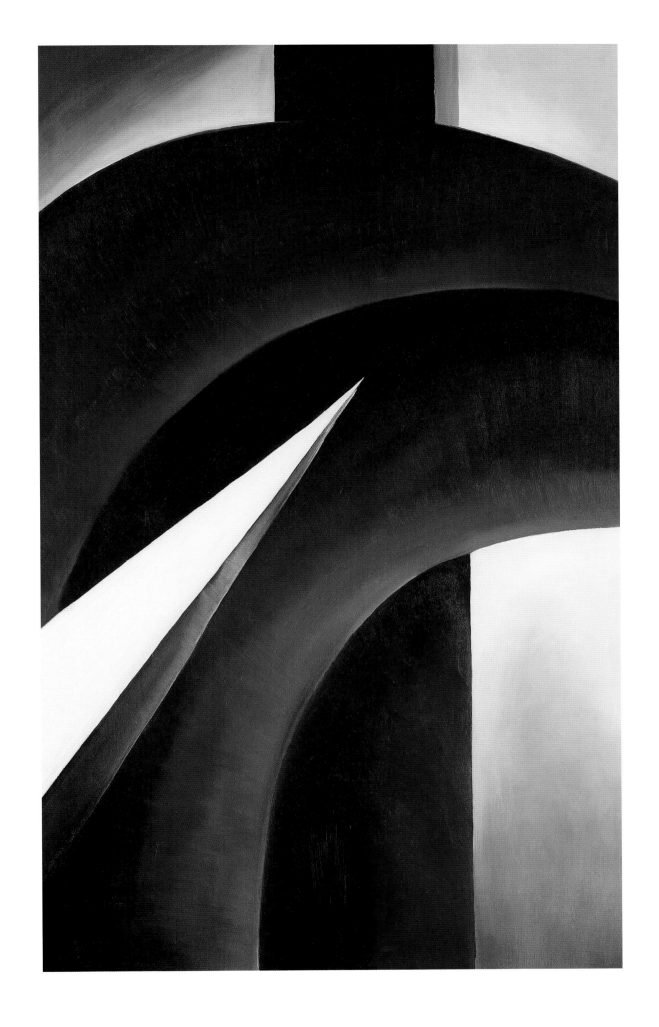

45.
*Jack-in-the-Pulpit Abstraction –
No. 5*, 1930
Oil on canvas
48 x 30 inches (121.9 x 76.2 cm)
National Gallery of Art,
Washington. Alfred Stieglitz
Collection. Bequest of Georgia
O'Keeffe

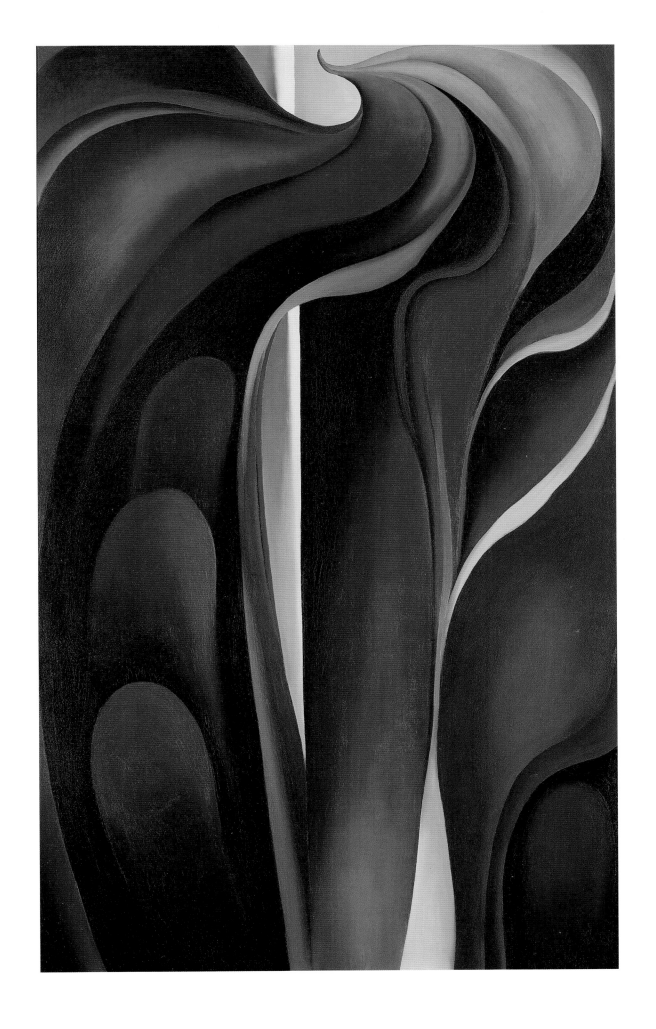

"I was up before the sun and out early to work. Such a beautiful, untouched lonely-feeling place—part of what I call the Far Away. It was a fine morning, sunny and clear, but soon the wind began to blow and it blew hard all day. I went on working. When I was ready to stop, there were clouds everywhere."
Georgia O'Keeffe, *Georgia O'Keeffe* (New York: Viking Press, 1976), p. 60

46.
*Soft Gray, Alcalde Hill**,
1929–30
Oil on canvas
10 1/8 x 24 1/8 inches
(25.5 x 61.2 cm)
Hirshhorn Museum and
Sculpture Garden, Smithsonian
Institution, Washington DC. Gift
of Joseph H. Hirschhorn, 1972

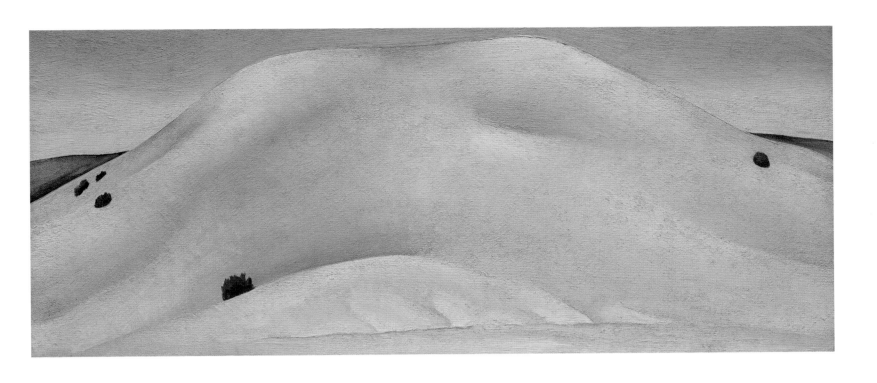

"A red hill doesn't touch everyone's heart as it touches mine and
I suppose there is no reason why it should. The red hill is a piece of
the badlands where even the grass is gone. Badlands roll away outside
my door——hill after hill——red hills of apparently the same sort
of earth that you mix with oil to make paint. All the earth colors of
the painter's palette are out there in the many miles of badlands."
"About Myself," exhibition catalogue, An American Place,
New York, 1939

47.
*Rust Red Hills**, 1930
Oil on canvas
16 x 30 inches (40.6 x 76.2 cm)
Brauer Museum of Art,
Valparaiso University. Sloan
Fund Purchase

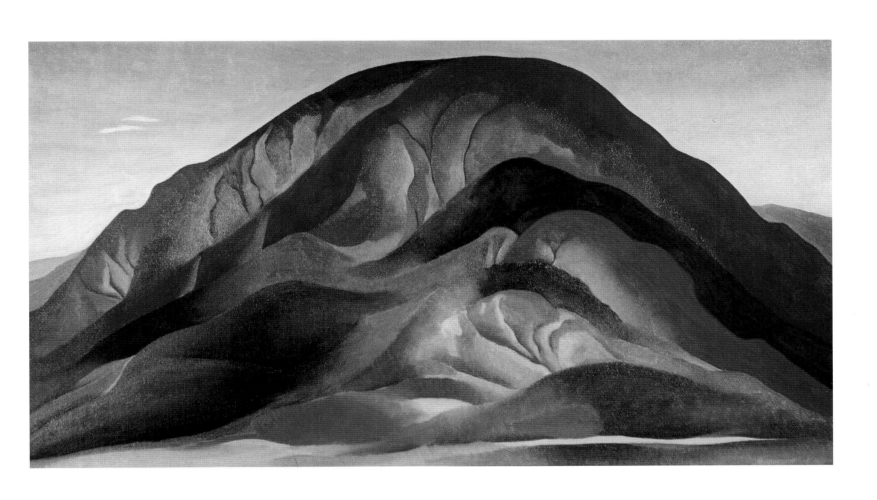

48.
Bear Lake, 1931
Oil on canvas
16 ¹/₂ x 36 ¹/₂ inches
(41.8 x 92.6 cm)
Collection of the Museum of
Fine Arts, New Mexico, USA.
Gift of the Museum of New
Mexico Foundation, 1984

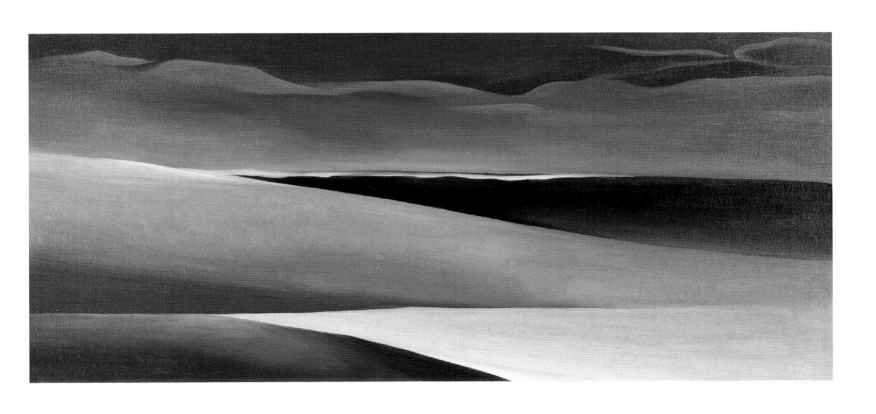

49.

*From a New Jersey Weekend II**, 1941
Oil on canvas
36 x 24 inches (91.4 x 61 cm)
Princeton University Art Museum. Gift of the Georgia O'Keeffe Foundation

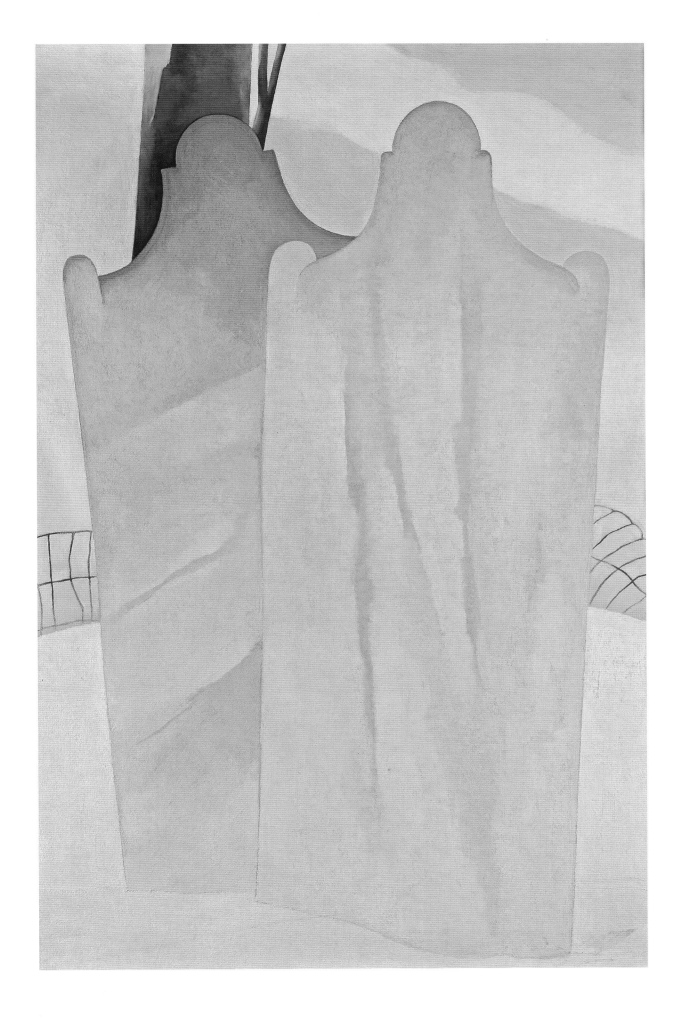

"I have picked flowers where I found them—have picked up sea shells and rocks and pieces of wood where there were sea shells and rocks and pieces of wood that I liked... When I found the beautiful white bones on the desert I picked them up and took them home too... I have used these things to say what is to me the wideness and wonder of the world as I live in it."

Georgia O'Keeffe, *Georgia O'Keeffe* (New York: Viking Press, 1976), p. 71

50.
*Pelvis with Distance**, 1943
Oil on canvas
24 x 30 inches (61 x 76.2 cm)
Indianapolis Museum of Art.
Gift of Ann Marmon Greenleaf
in memory of Caroline Marmon
Fesler [1977]

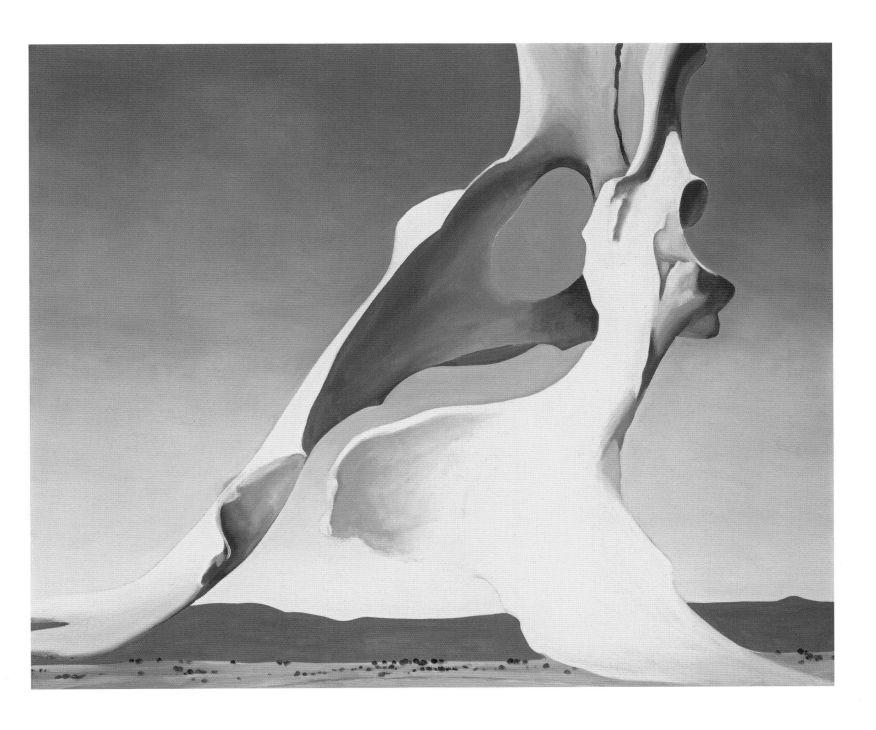

"A pelvis bone has always been useful to any animal that has it— quite as useful as a head, I suppose. For years in the country the pelvis bones lay about the house indoors and out seen and not seen as such things can be—seen in many different ways. I do not remember picking up the first one but I remember from when I first noticed them always knowing I would one day be painting them." Georgia O'Keeffe, *Georgia O'Keeffe* (New York: Viking Press, 1976), p. 73

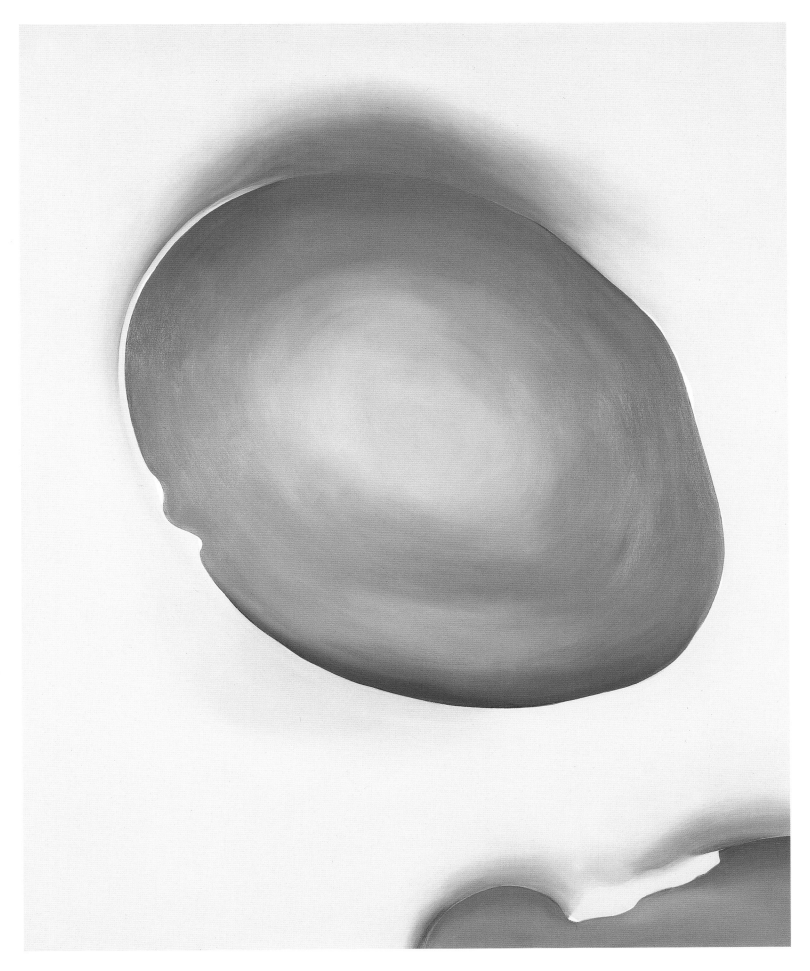

133

52.
Abstraction, 1945 (modeled
in 1946, cast 1979–80)*
White cast epoxy
36 x 36 x 4 ¹/₂ inches
(91.4 x 91.4 x 10.7 cm)
1 of an edition of 3 in epoxy
Courtesy Gerald Peters Gallery,
New York

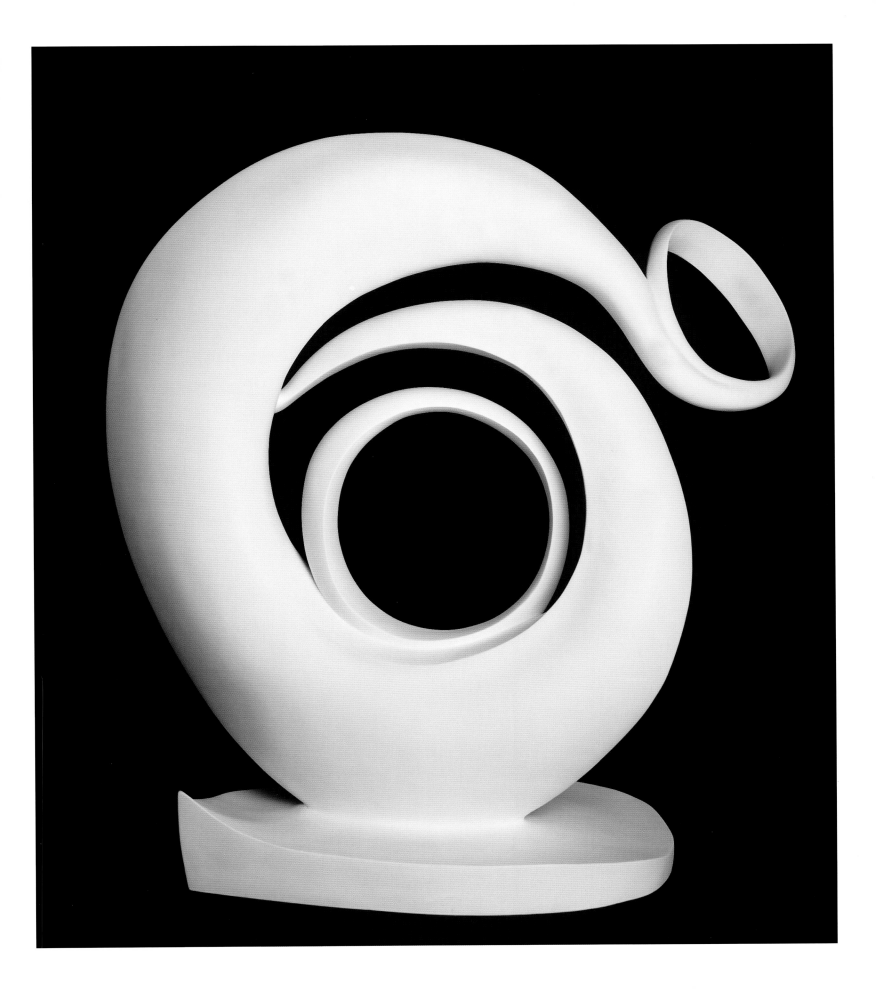

53.
Black Place I, 1944
Oil on canvas
26 x 30 1/8 inches (66 x 76.5 cm)
San Francisco Museum of
Modern Art. Gift of Charlotte
Mack 54.3536

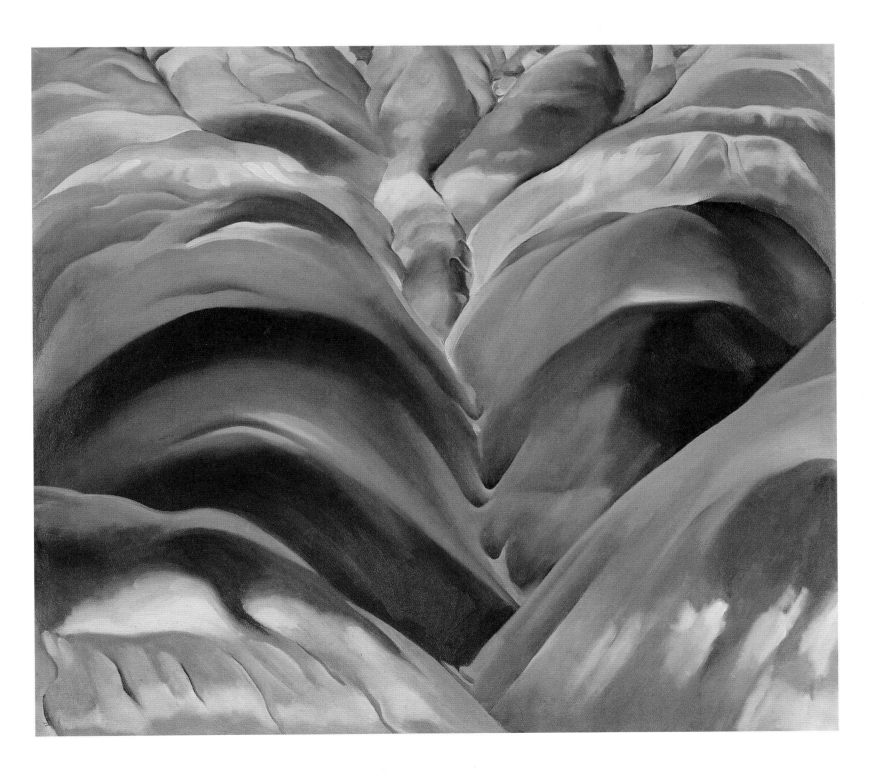

"I must have seen the Black Place first driving past on a trip into the Navajo country and, having seen it, I had to go back to paint——even in the heat of mid-summer.
It became one of my favorite places to work."
Georgia O'Keeffe, *Georgia O'Keeffe* (New York: Viking Press, 1976), p. 59

54.
Black Place II, 1944
Oil on canvas
24 x 30 inches (61 x 76.2 cm)
The Metropolitan Museum of
Art, Alfred Stieglitz Collection,
1950 (50.236.1)

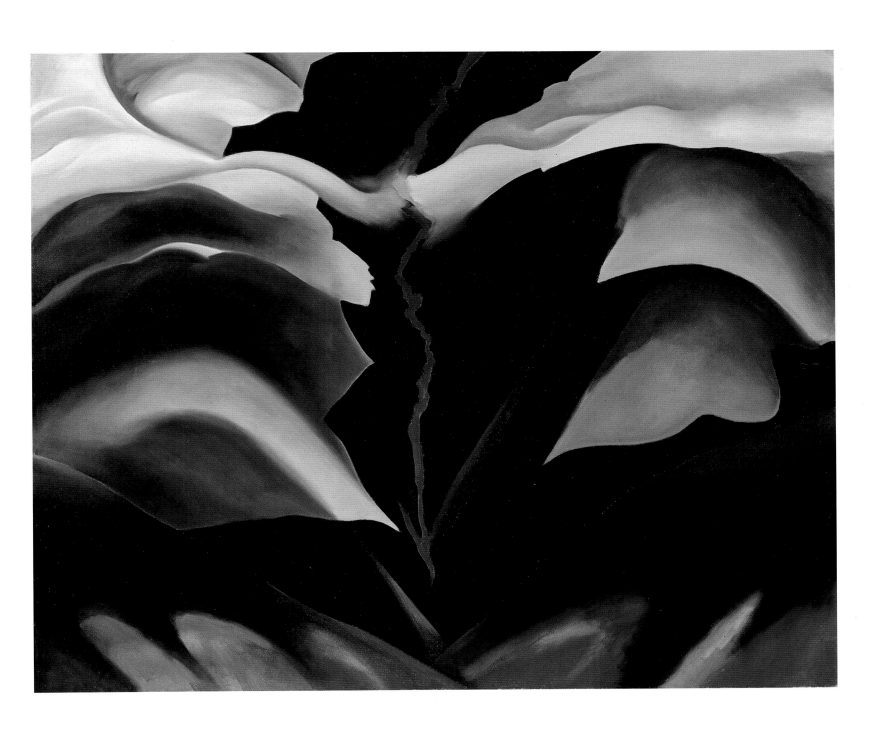

55.
Black Place, Grey and Pink,
1949
Oil on canvas
36 x 48 inches
(91.4 x 121.9 cm)
Santa Fe, The Georgia O'Keeffe
Museum

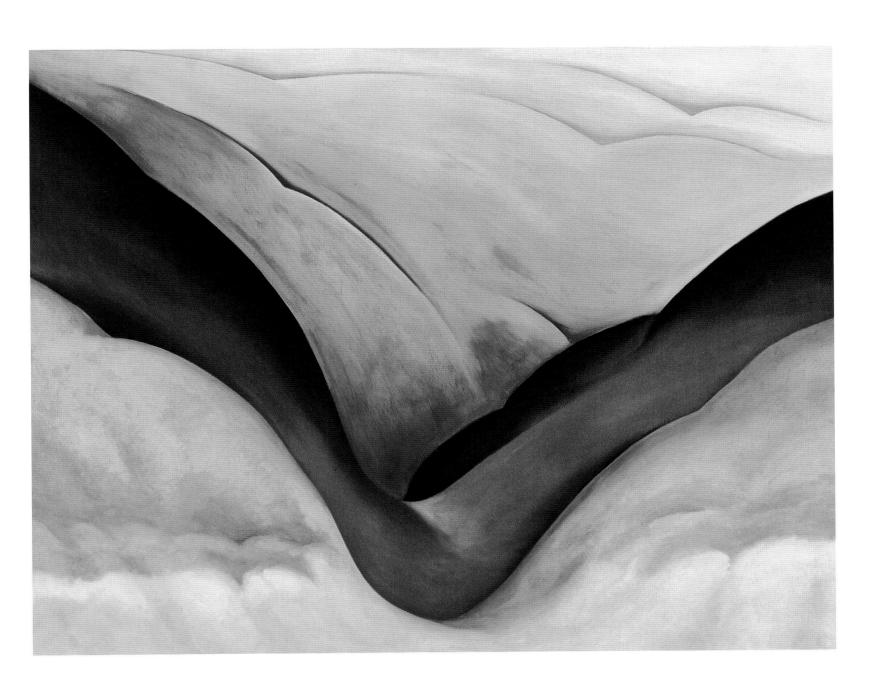

56.
*Dark Tree Trunks**, 1946
Oil on canvas
40 x 30 inches
(101.6 x 76.2 cm)
Brooklyn Museum. 87.136.1.
Bequest of Georgia O'Keeffe

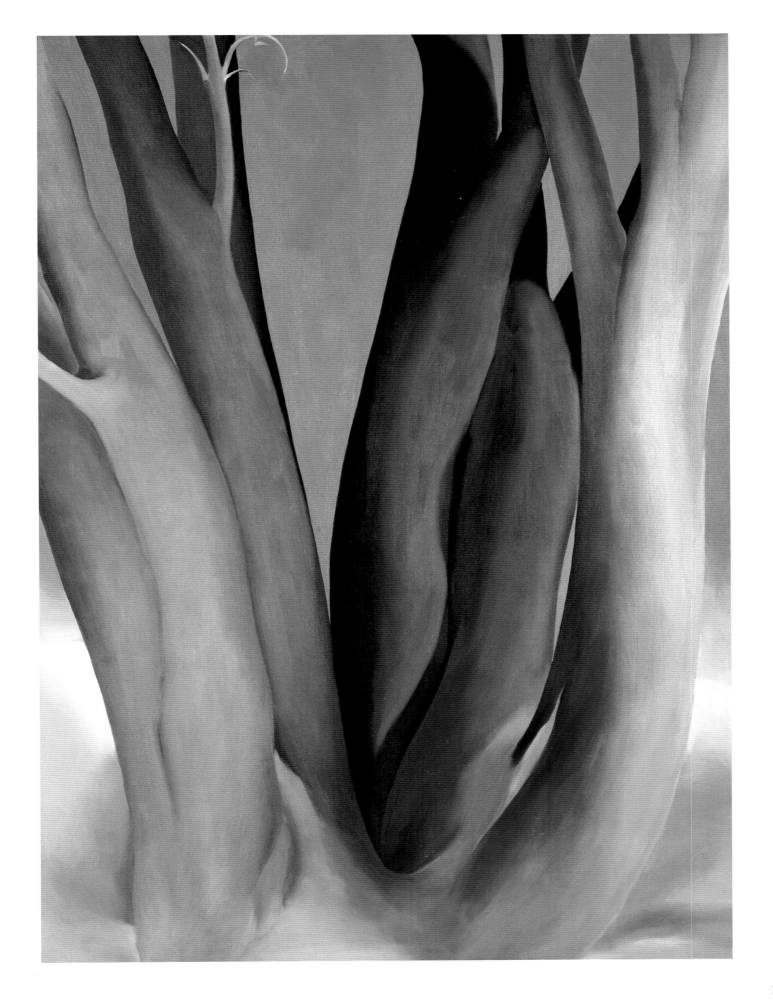

57.
Waterfall I, 1952
Oil on canvas
32 ³/₈ x 18 ³/₈ inches
(82.1 x 46.6 cm)
The Baltimore Museum of Art:
Edward Joseph Gallagher III
Memorial Collection BMA
1959.17

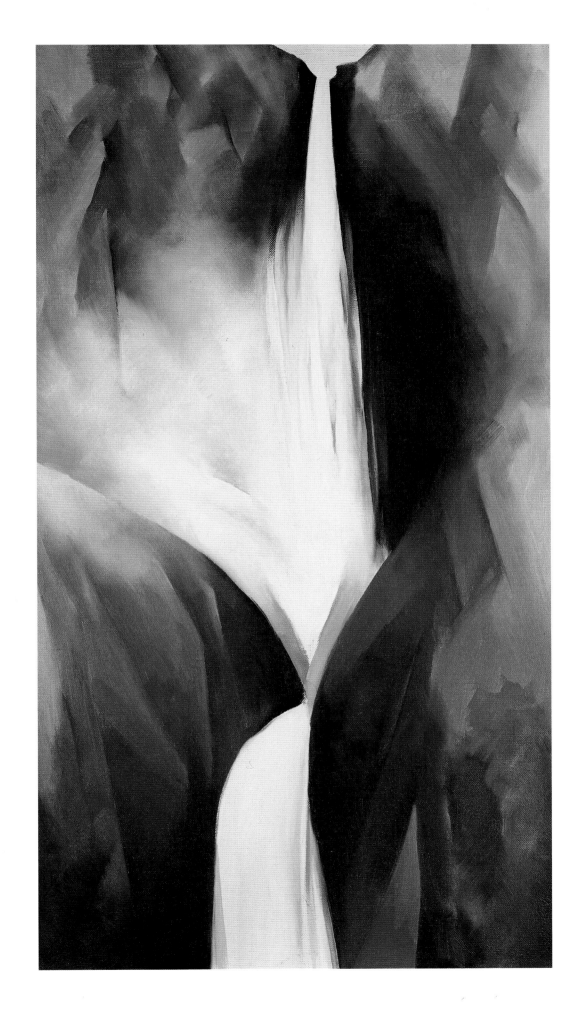

58.
In the Patio II, 1948
Oil on linen
18 x 30 inches (45.7 x 76.2 cm)
Collection of the Museum of
Fine Arts, New Mexico, USA.
Bequest of Helen Miller Jones,
1986

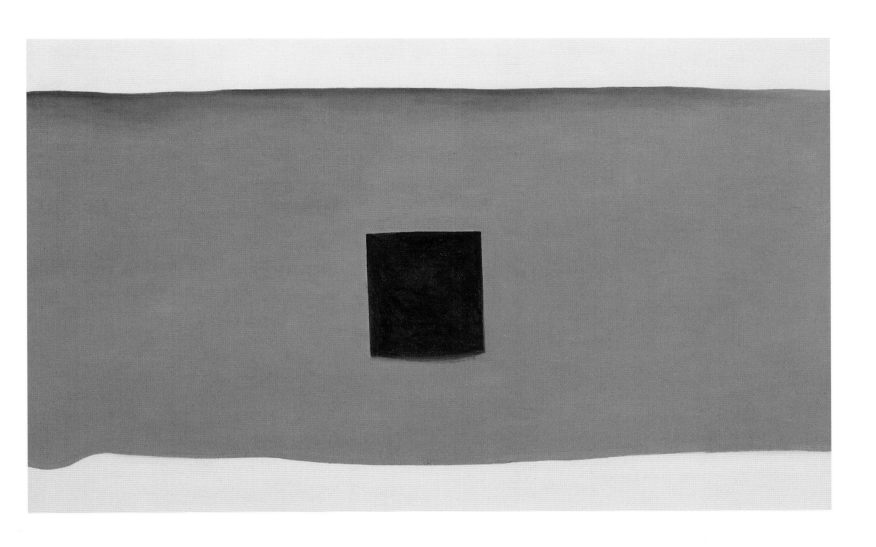

"When I first saw the Abiquiu house it was a ruin with an adobe wall around the garden broken in a couple of places by falling trees. As I climbed and walked about in the ruin I found a patio with a very pretty well house and bucket to draw up water. It was a good-sized patio with a long wall with a door on one side. That wall with a door in it was something I had to have….that wall with a door was painted many times."

Georgia O'Keeffe, *Georgia O'Keeffe* (New York: Viking Press, 1976), p. 82

59.
*Wall with Green Door**, 1953
Oil on canvas
30 $\frac{1}{4}$ x 47 $\frac{7}{8}$ inches
(76.8 x 121.7 cm)
Corcoran Gallery of Art,
Washington, DC. Gift of the
Woodward Foundation

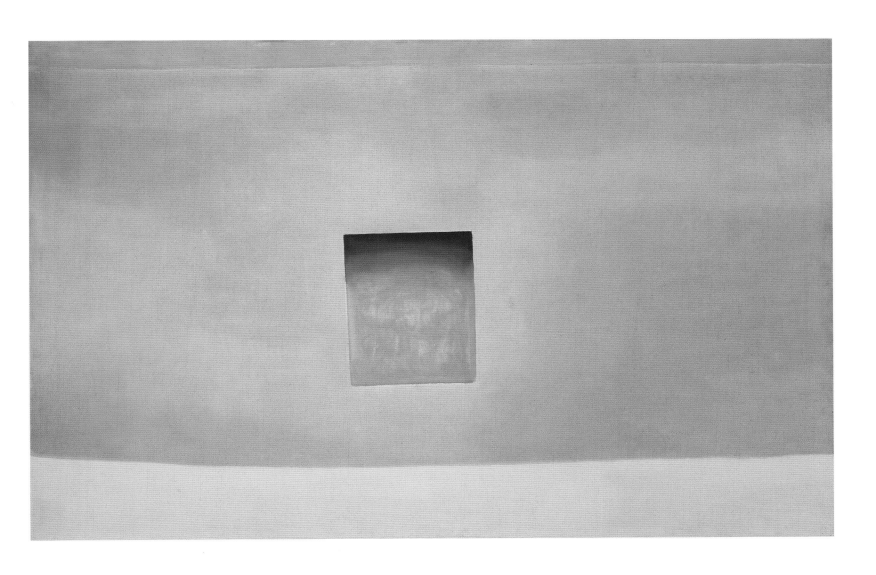

60.
From the Plains, 1952–54
Oil on canvas
47 $^{11}/_{16}$ x 83 $^{5}/_{8}$ inches
(121 x 213.5 cm)
Collection of the McNay Art
Museum. Gift of the Estate
of Tom Slick

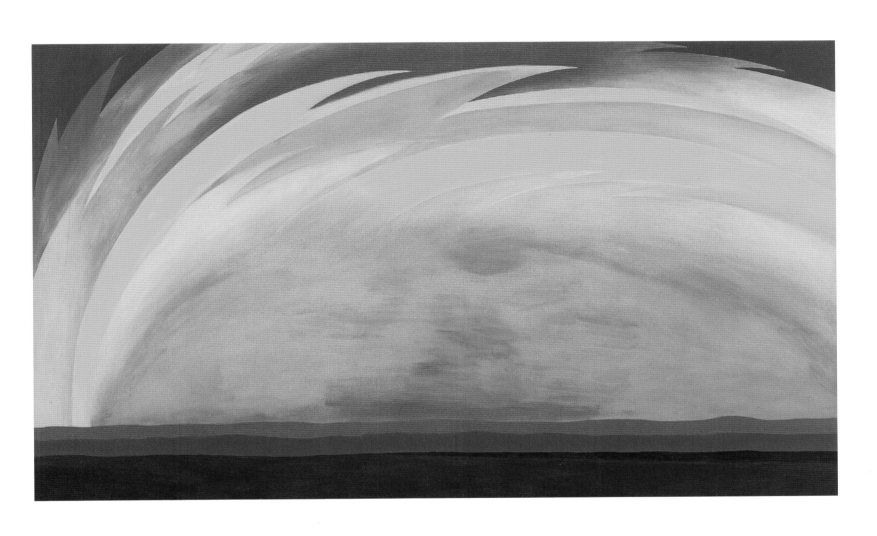

"*I know I can not paint a flower. I can not paint the sun on the desert on a bright summer morning but maybe in terms of paint color I can convey to you my experience of the flower or the experience that makes the flower of significance to me at that particular time. Color is one of the great things in the world that makes life worth living to me and as I have come to think of painting it is my efforts to create an equivalent with paint color for the world—life as I see it.*" Letter to William M. Milliken (Director, Cleveland Art Museum), November 1, 1930

61.
*From the Plains II**, 1954
Oil on canvas
48 x 72 inches (121.9 x 183 cm)
Museo Thyssen-Bornemisza,
Madrid

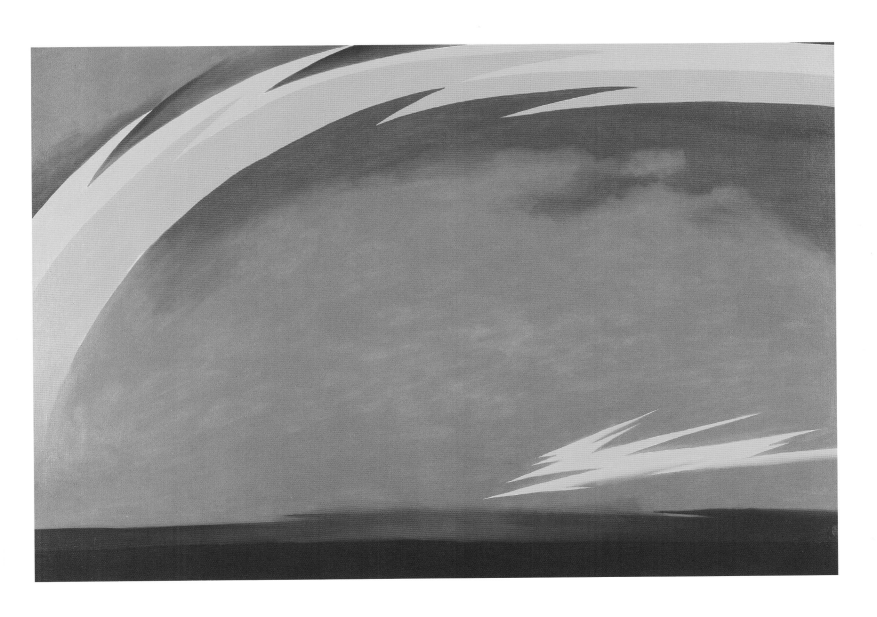

62.
My Last Door, 1952–54
Oil on canvas
48 x 84 inches
(121.9 x 213.4 cm)
Santa Fe, The Georgia O'Keeffe
Museum

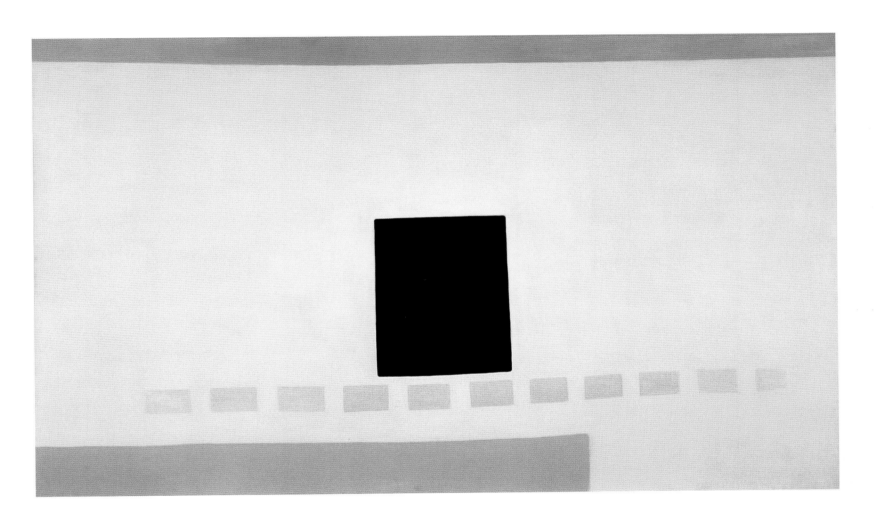

63.
*Black Door with Red**, 1954
Oil on canvas
48 x 84 inches
(121.9 x 213.4 cm)
Chrysler Museum of Art,
Norfolk, Virginia. Bequest of
Walter P. Chrysler, Jr.

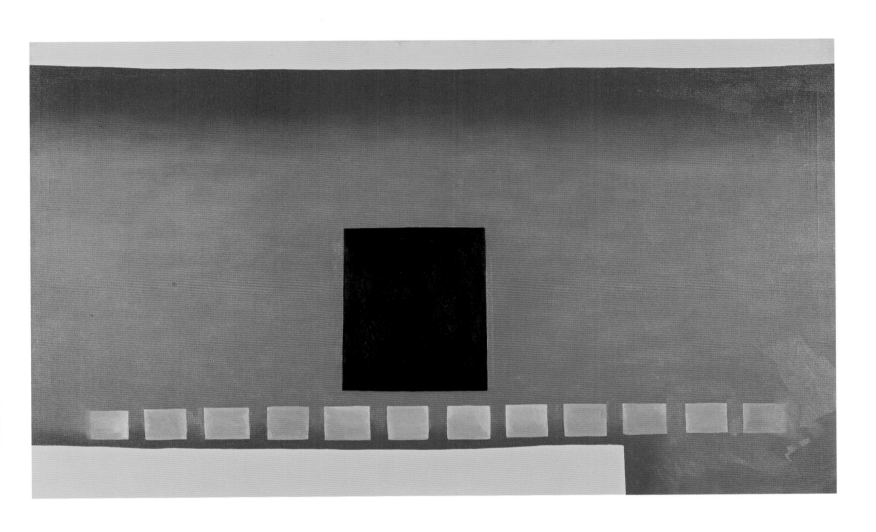

64.
Black Patio Door, 1955
Oil on canvas
40 ⅛ x 30 inches
(101.9 x 76.2 cm)
Amon Carter Museum,
Fort Worth, Texas
Georgia O'Keeffe 1966.19

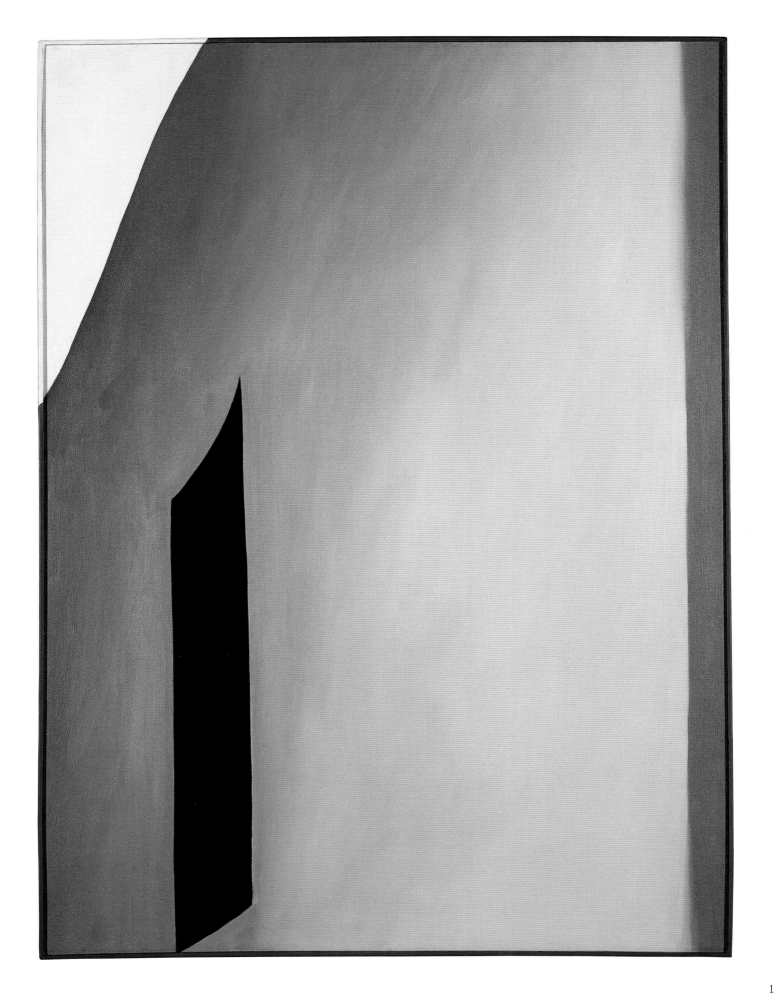

65.
Blue II, 1958
Oil on canvas
30 x 26 inches (76.2 x 66 cm)
Santa Fe, The Georgia O'Keeffe
Museum

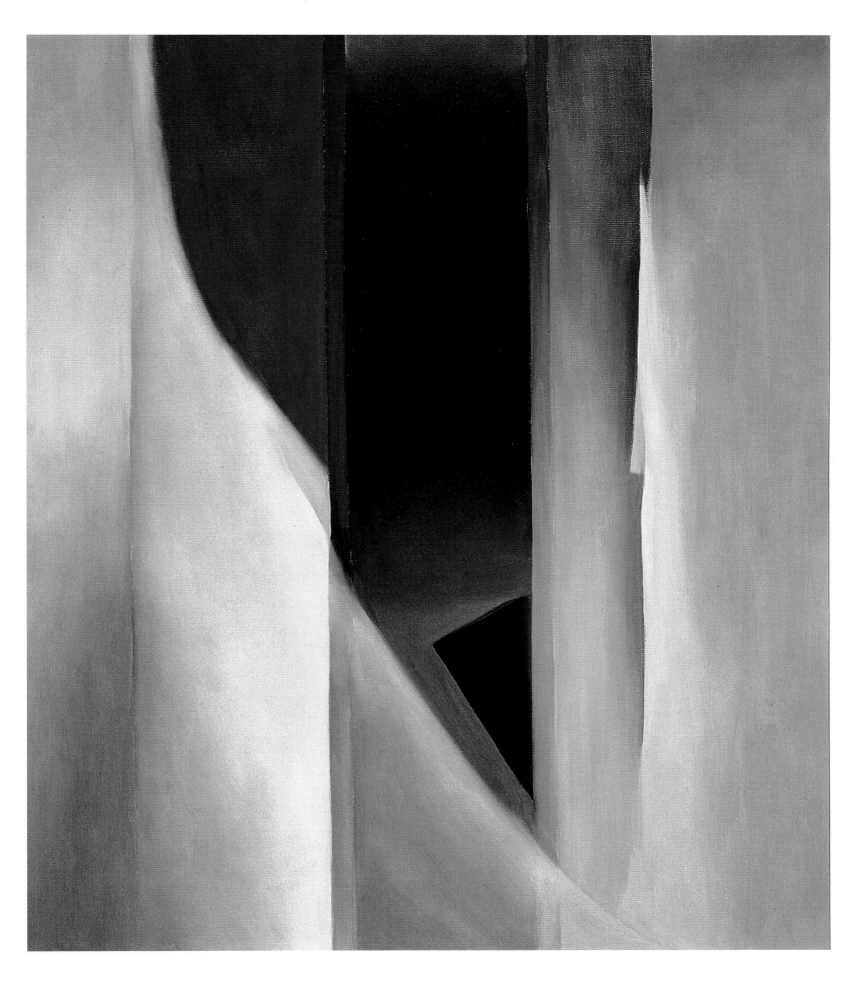

161

66.
Blue B, 1959
Oil on canvas
30 x 36 inches (76.2 x 91.4 cm)
Milwaukee Art Museum. Gift
of Mrs. Harry Lynde Bradley,
M1973.606

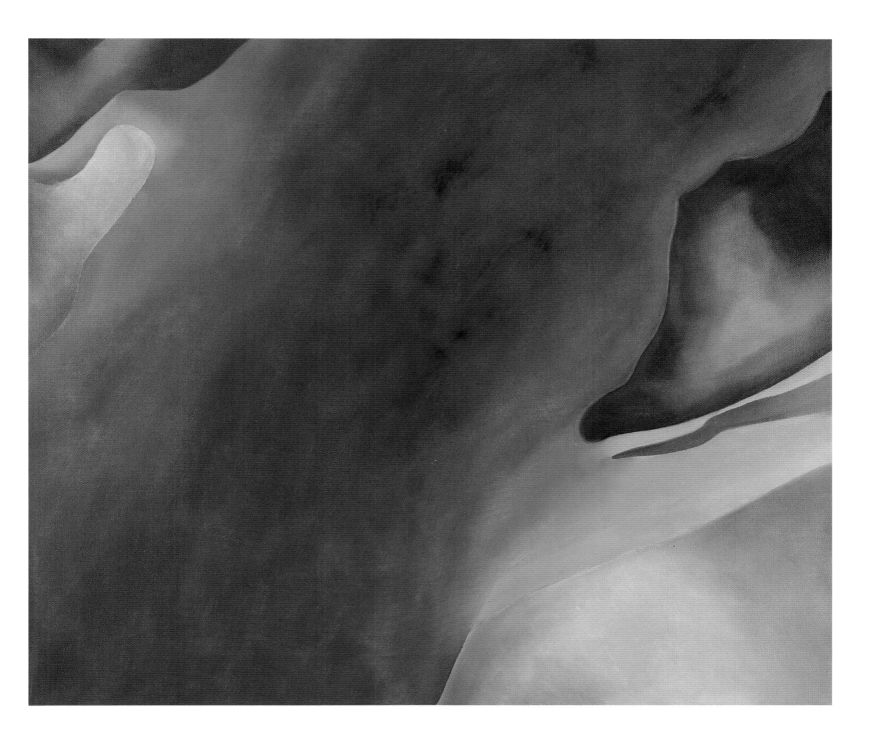

67.
It Was Red and Pink, 1959
Oil on canvas
30 x 40 inches (76.2 x 101.6 cm)
Milwaukee Art Museum, Gift
of Mrs. Harry Lynde Bradley,
M1977.135

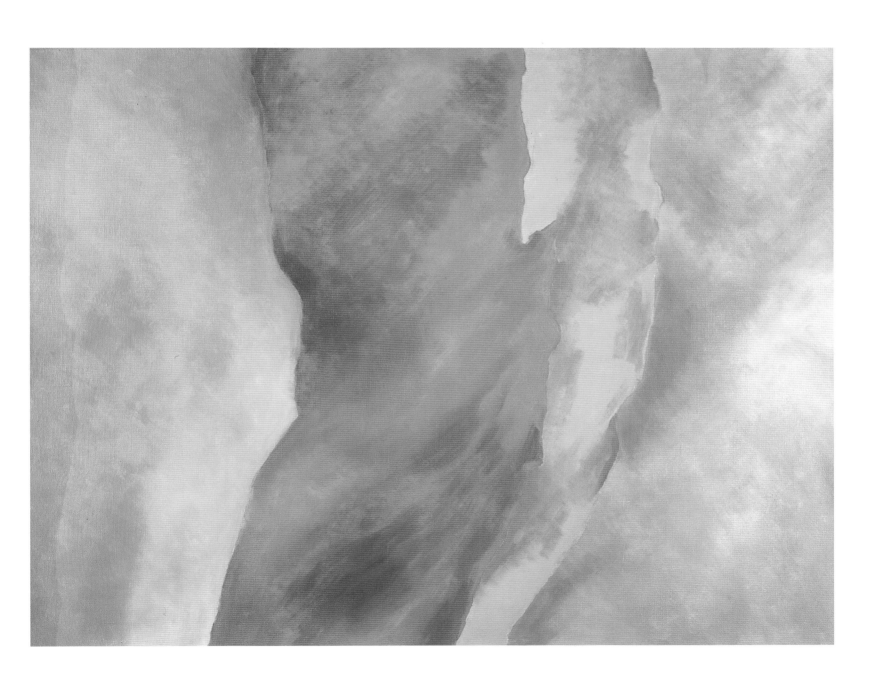

68.
Green Yellow and Orange, 1960
Oil on canvas
40 x 30 inches
(101.6 x 76.2 cm)
Brooklyn Museum. 87.136.3.
Bequest of Georgia O'Keeffe

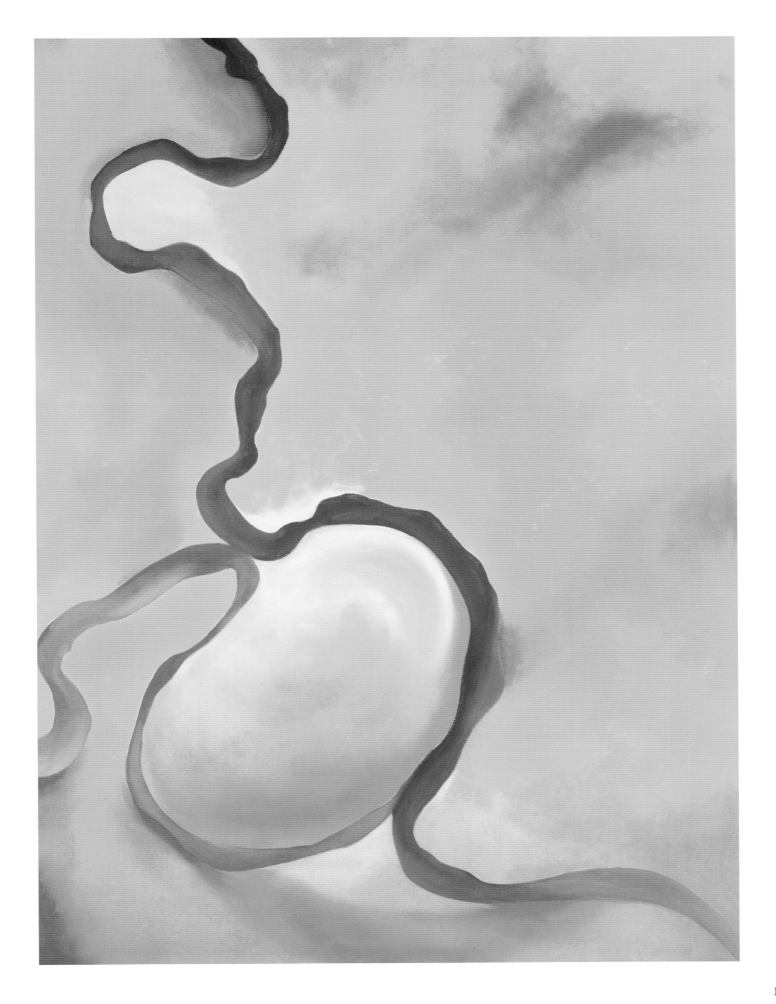

"I am afraid of flying—but after the plane takes off I enjoy what I see from the air and forget the hazards. I once spent three and a half months flying around the world. I was surprised that there were so many desert areas with large riverbeds running through them. I made many drawings about one and a half inches square of the rivers seen from the air. At home I made larger charcoal drawings from the little pencil drawings. Later I made paintings from the charcoal drawings. The color used for the paintings had little to do with what I had seen—the color grew as I painted."

Georgia O'Keeffe, *Georgia O'Keeffe* (New York: Viking Press, 1976), p. 103

69.
*It Was Blue and Green**, 1960
Oil on canvas mounted
on composition board
30 1/6 x 40 1/8 inches
(76.3 x 101.9 cm)
Whitney Museum of American
Art, New York. Lawrence
H. Blondel Bequest 77.1.37

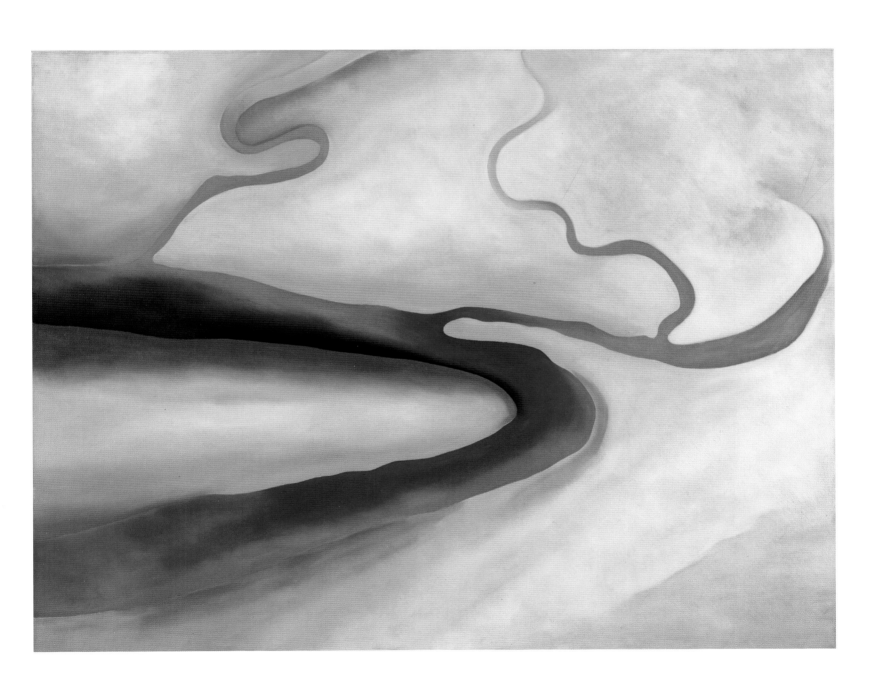

70.
It Was Yellow and Pink III, 1960
Oil on canvas
40 x 30 inches (101.6 x 76.2 cm)
Alfred Stieglitz Collection.
Bequest of Georgia O'Keeffe,
1987.250.2, The Art Institute
of Chicago

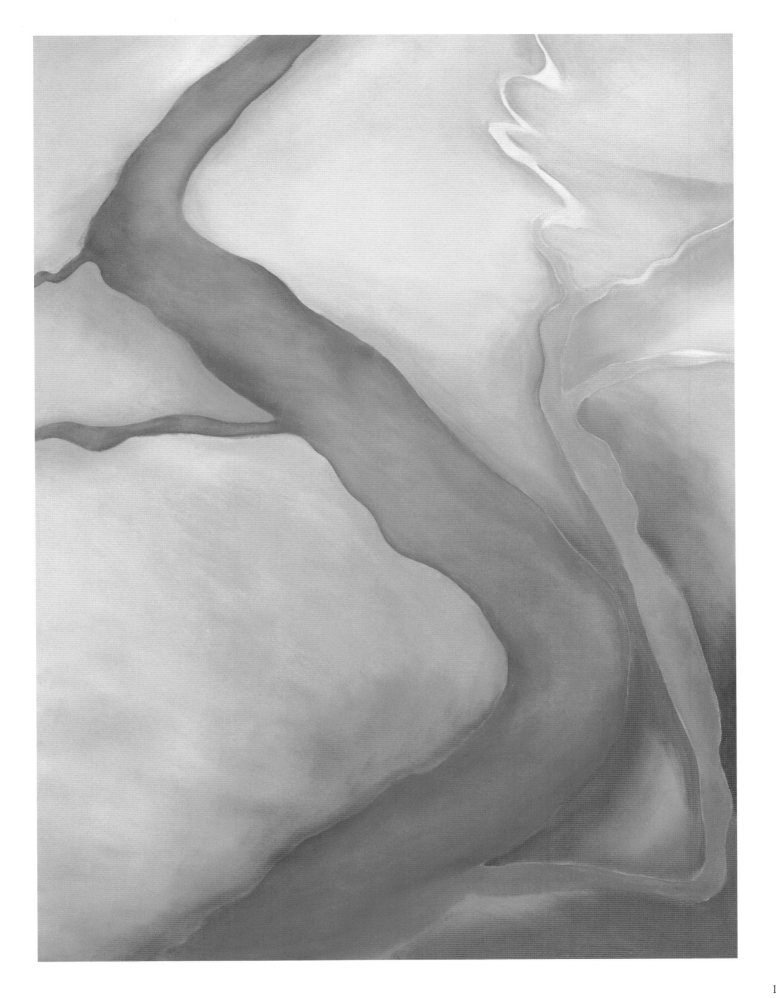

"It is breathtaking as one rises up over the world one has been living in—looking out at—and looks down at it stretching away and away. The Rio Grande—the mountains—then the pattern of rivers—ridges—washes—roads—fields—water holes—wet and dry—Then little lakes—a brown pattern—then after a while as we go over the Amarillo country, a fascinating restrained pattern of different greens and cooler browns … What one sees from the air is so simple and so beautiful I cannot help feeling that it would do something wonderful for the human race—rid it of much smallness and pettishness if more people flew—However, I am probably wrong because I will probably not really be very different when I get my feet on the earth than I was when they left it."
Letter to Maria Chabot, November 1941

71.
Pink and Green, 1960
Oil on canvas
30 x 16 inches (76.2 x 40.6 cm)
Santa Fe, The Georgia O'Keeffe Museum

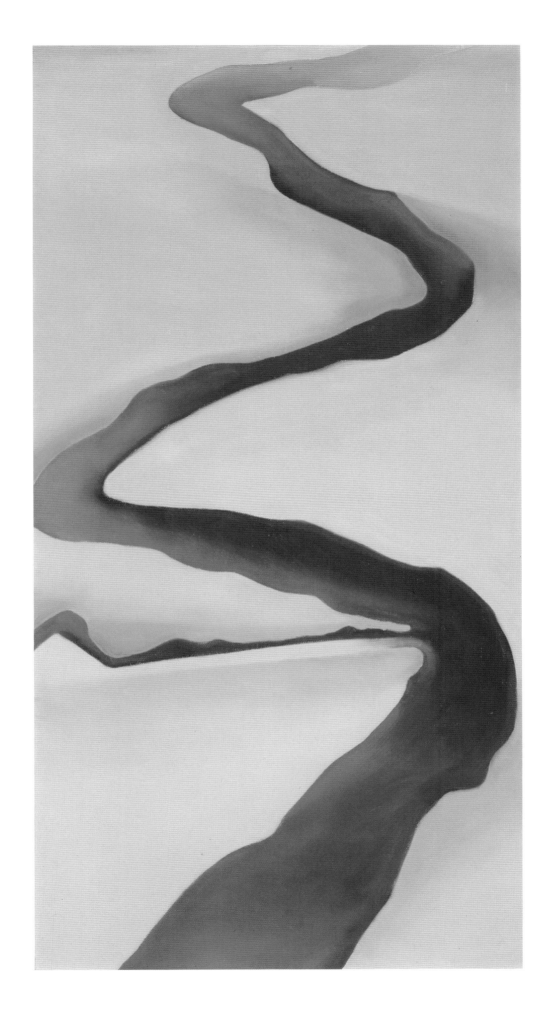

"One day when I was flying back to New Mexico, the sky below was a most beautiful solid white. It looked so secure that I thought I could walk right out on it to the horizon if the door opened. The sky beyond was a light clear blue. It was so wonderful that I couldn't wait to be home to paint it."

Georgia O'Keeffe, *Georgia O'Keeffe* (New York: Viking Press, 1976), p. 106

72.
Sky with Flat White Cloud,*
1962
Oil on canvas
60 x 80 inches
(152.3 x 203.1 cm)
National Gallery of Art,
Washington. Alfred Stieglitz
Collection. Bequest of Georgia
O'Keeffe

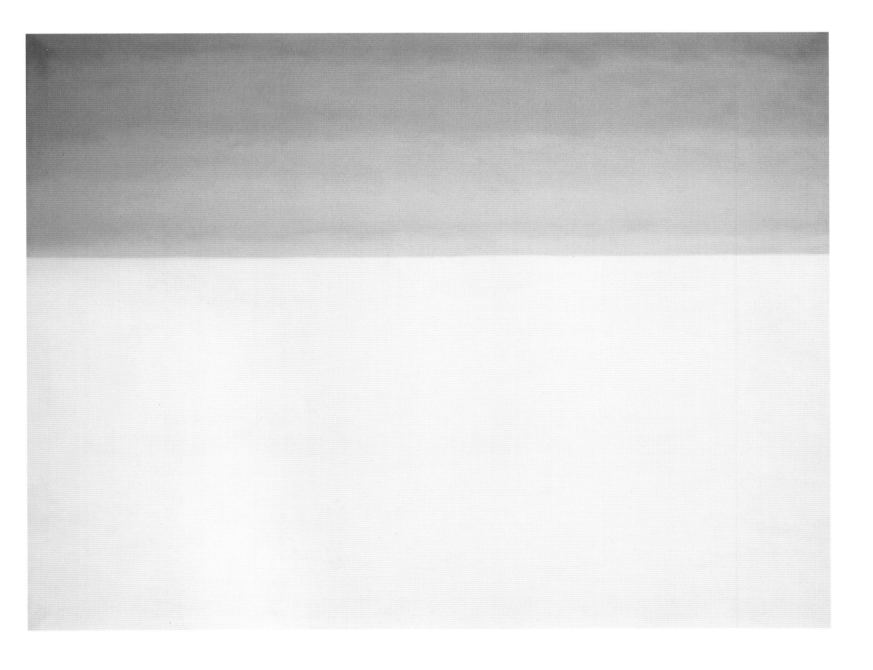

73.
Above the Clouds I, 1962–63
Oil on canvas
36 1/8 x 48 1/4 inches
(91.7 x 122.6 cm)
Santa Fe, The Georgia O'Keeffe
Museum

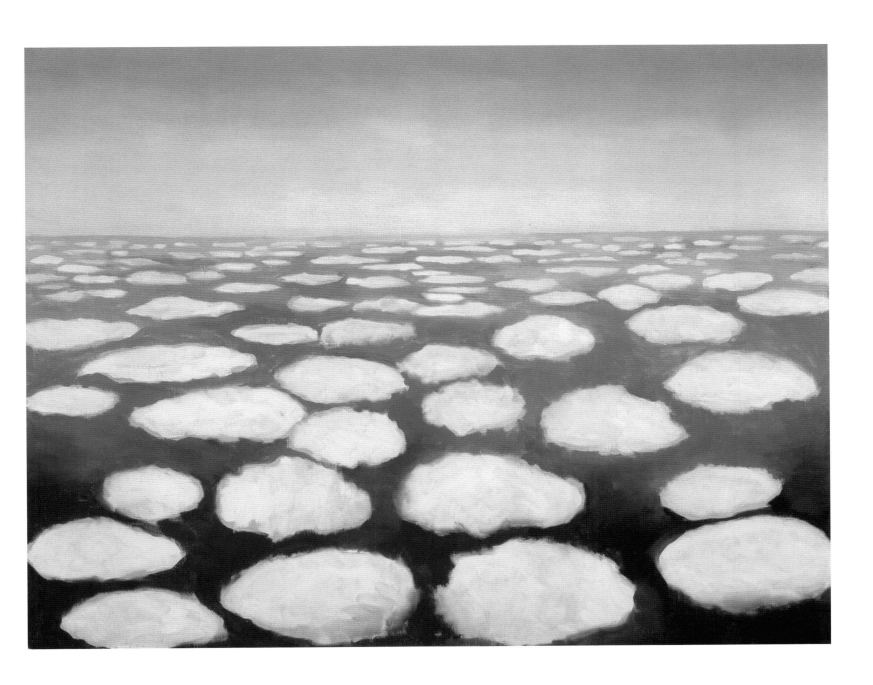

"Two walls of my room in the Abiquiu house are glass and from one window I see the road toward Espanola, Santa Fe, and the world. The road fascinates me with its ups and downs and finally its wide sweep as it speeds toward the wall of my hilltop to go past me. I had made two or three snaps of it with a camera. For one of them I turned the camera at a sharp angle to get all the road. It was accidental that I made the road seem to stand up in the air, but it amused me and I began drawing and painting it as a new shape. The trees and mesa beside it were unimportant for that painting—it was just the road."

Georgia O'Keeffe, *Georgia O'Keeffe* (New York: Viking Press, 1976), p. 104

74.
*Winter Road I**, 1963
Oil on canvas
22 x 18 inches (55.9 x 45.7 cm)
National Gallery of Art, Washington. Alfred Stieglitz Collection. Bequest of Georgia O'Keeffe

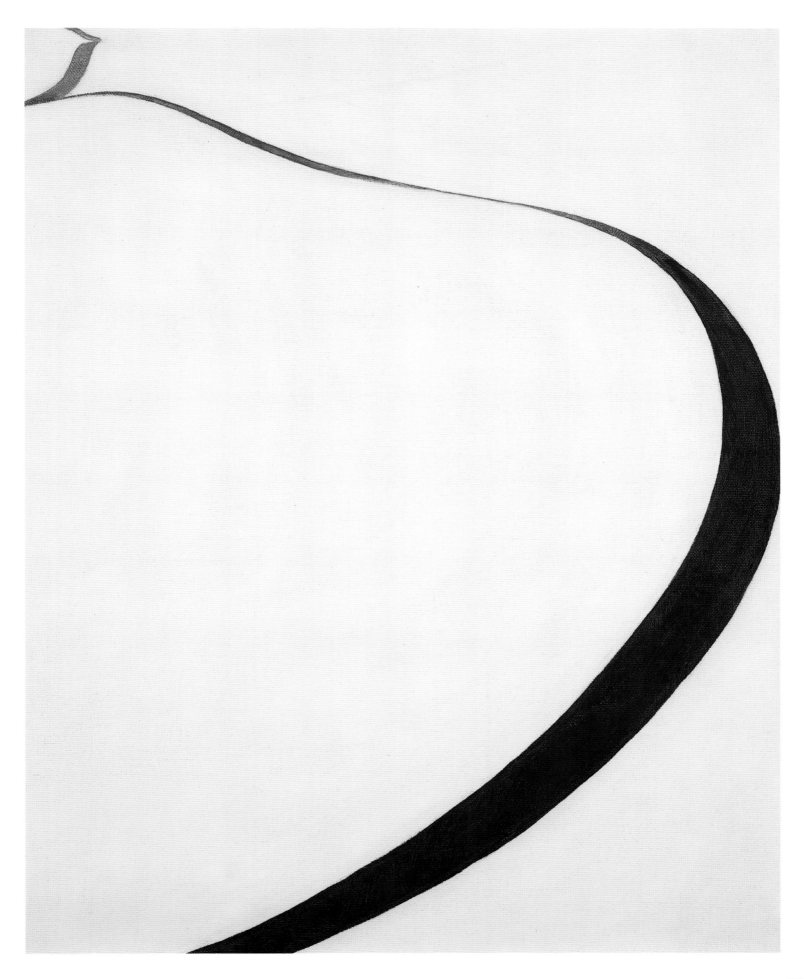

75.
On the River, 1964
Oil on canvas
40 x 30 inches
(101.6 x 76.2 cm)
Collection of the Museum of
Fine Arts, New Mexico, USA.
Gift of the Estate of Georgia
O'Keeffe, 1987

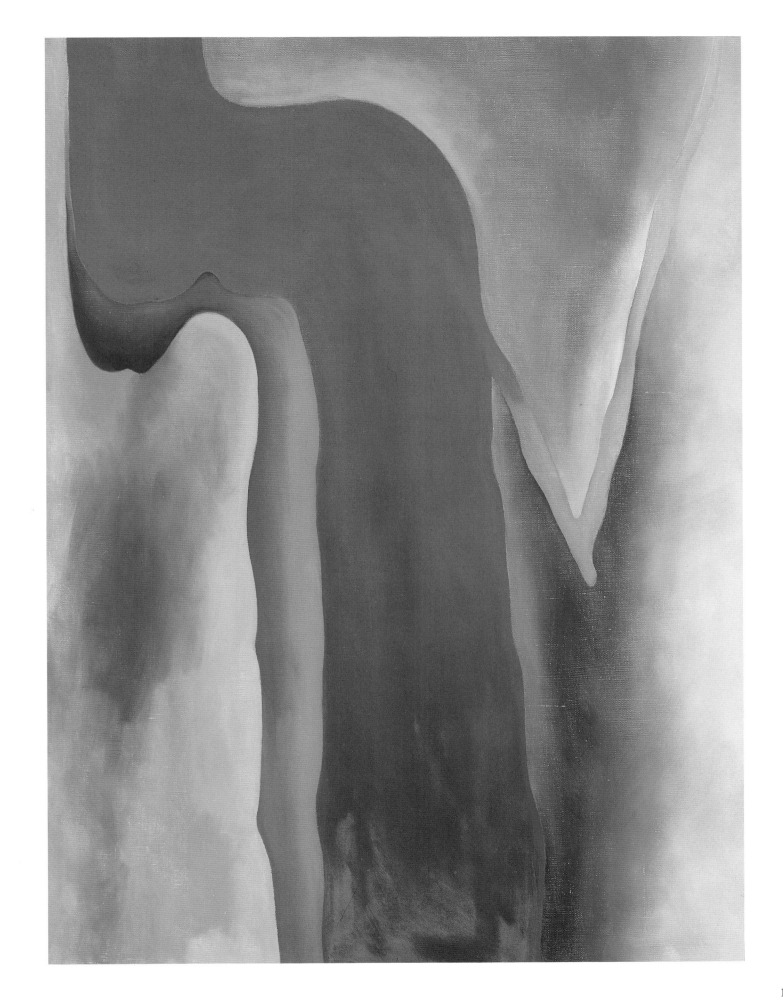

"The rows of little hills… at Ghost Ranch must have been formed by thousands of years of erosion by wind and rain. The hills look soft and gentle but they are so steep and stubborn that there are only a few places where you can climb up or down, usually on the old cattle trails… I had looked out on the hills for weeks and painted them again and again—had climbed and ridden over them—so beautifully soft, so difficult."

Georgia O'Keeffe, *Georgia O'Keeffe* (New York: Viking Press, 1976), p. 70

76.
*Canyon Country**, c. 1965
Oil on canvas
30 x 40 inches
(76.2 x 101.6 cm)
Collection of Phoenix Art Museum. Gift of The Georgia O'Keeffe Foundation

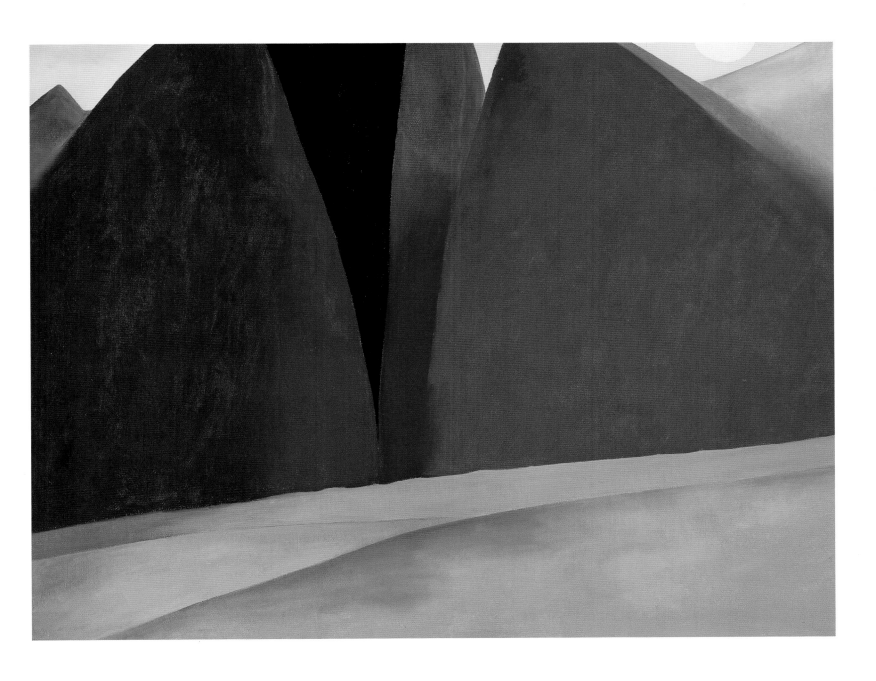

77.
From a Day with Juan II,*
1976–77
Oil on canvas
48 x 36 inches (121.9 x 91.4 cm)
New York, Museum of Modern
Art (MoMA). Georgia O'Keeffe
Bequest. Acc. no.: 447.1994

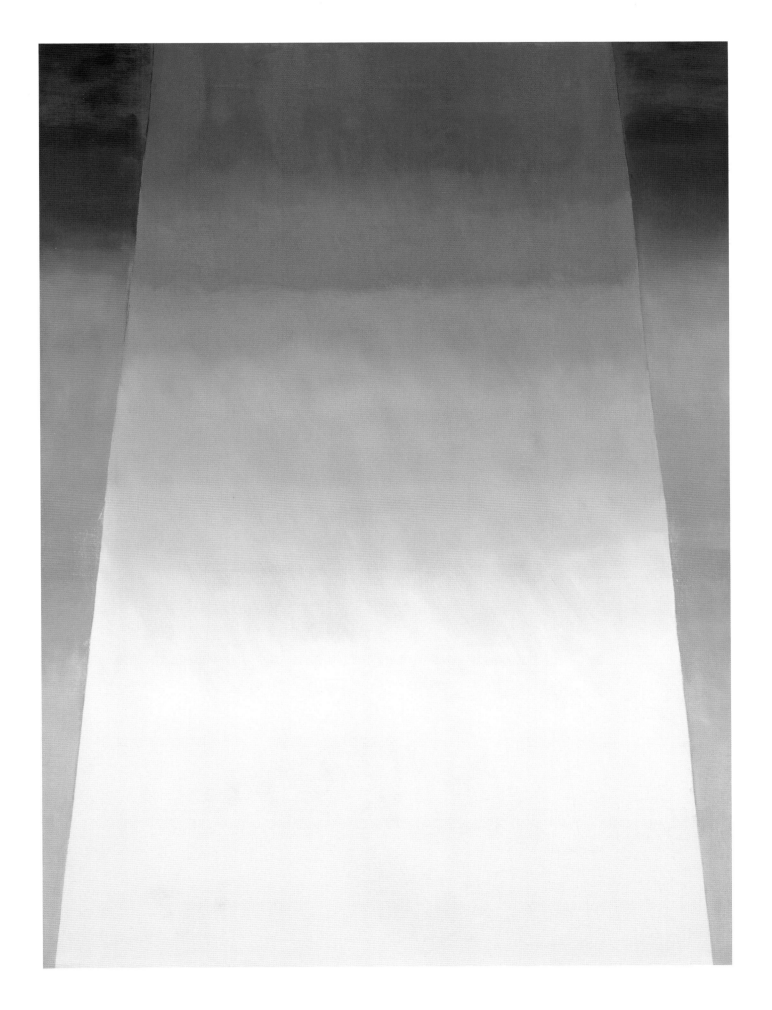

Chronology

1848

Georgia O'Keeffe's paternal grandparents, Pierce O'Keeffe and Catherine Mary Shortall, left County Cork, Ireland, and sailed to America, where they continued by boat along the Great Lakes to Milwaukee, and then by oxcart to Sun Prairie, Wisconsin.

1887

Georgia O'Keeffe was born near Sun Prairie, Wisconsin, November 15, 1887, the daughter of Francis and Ida (Totto) O'Keeffe, the second of seven brothers and sisters.

1888–1905

Her childhood was spent on the family's 600–acre farm. Early schooling was in a nearby country school, then in Madison, Wisconsin, and her last two years of high school spent at Chatham Episcopal Institute, Chatham, Virginia. The O'Keeffe family moved to Williamsburg, Virginia, in 1902.

1905–06

Attended Art Institute of Chicago, where she studied with John Vanderpoel. Suffered a long illness of typhoid fever and recuperation in Williamsburg.

1907–08

Attended Art Students League, New York, where she studied with William Merritt Chase, F. Luis Mora, and Kenyon Cox. Visit to a Rodin exhibition at Alfred Stieglitz's gallery, 291, with other art students. Awarded the Chase Still Life Scholarship, which allowed her to attend summer classes at the League Outdoor School at Lake George, New York.

1909–14

Decided to give up painting, and moved to Chicago where she held two jobs in commercial art. Mother's illness caused the family to move to Charlottesville, Virginia. In summer 1912, visited art class at University of Virginia given by Alon Bement, a teacher under Arthur Dow, which led to a renewed interest in painting. In autumn 1912, started teaching art in public schools in Amarillo, Texas. In summer 1913 (also summers of 1914–16), taught at the University of Virginia Art Department. In autumn 1914, traveled to New York to study with Arthur Dow at Teachers College, Columbia University.

1915

Took a teaching position at Columbia College, Columbia, South Carolina, in order to allow more time for her own work. Unhappy with her work, decided to start over, working on ideas only her own in black charcoal on paper. Sent drawings to a New York friend, Anita Pollitzer, with instructions to show them to no one. Excited by the work, Pollitzer took several to Alfred Stieglitz who was so interested that he kept them.

1916

In May, exhibition of early drawings and watercolors at 291 (along with paintings by Charles Duncan and Rene Lafferty) without O'Keeffe's knowledge, and before she and Stieglitz had met. First met Stieglitz when she went to 291 to have works taken down, but they remained on view through July. In autumn, took position as head of Art Department at West Texas State Normal School, Canyon, Texas, where she taught for the next two years.

1917

In May, Stieglitz held first one-artist show of O'Keeffe work, as the gallery's final exhibition. O'Keeffe went to New York during June vacation and found the gallery closed, but Stieglitz re-hung her show for her. First photographs of O'Keeffe by Stieglitz made at this time. During the fall, she and her sister, Claudia, traveled through Colorado and New Mexico, O'Keeffe's first visit to the area.

1918

Became ill and took leave of absence from teaching. Spent spring in San Antonio, Texas, and summer in New York at Stieglitz's suggestion. Stieglitz offered her a yearlong stay in New York to paint for herself. Lived for next ten years in New York, with summers spent at Stieglitz family home in Lake George, New York.

1923

Exhibition presented by Stieglitz at the Anderson Galleries, New York, of one hundred pictures by Georgia O'Keeffe.

1924

Exhibition presented by Stieglitz at the Anderson Galleries of fifty-one recent O'Keeffe pictures, and a simultaneous exhibition of his own photographs. Began first large flower paintings. Married Alfred Stieglitz.

1925

Seven Americans exhibition held by Stieglitz at the Anderson Galleries. The first group exhibition of artists championed by Stieglitz: Charles Demuth, Arthur G. Dove, Marsden Hartley, John Marin, and Georgia O'Keeffe, and including two photographers, himself and Paul Strand.

1926–29

Yearly exhibitions of new work at Stieglitz's Intimate Gallery, New York.

1927

Retrospective exhibition at the Brooklyn Museum, New York.

1929

Summer trip to New Mexico with Rebecca Strand. Stayed in Taos with Mabel Dodge Luhan. For the most part, summers now spent in New Mexico, and other seasons spent with Stieglitz in New York and Lake George.

1930–46

Yearly exhibitions of new work at Stieglitz's new gallery, An American Place.

1934

First summer at Ghost Ranch, north of Abiquiu, New Mexico. Returned to Ghost Ranch in 1935, and purchased in 1940.

1939

Chosen one of twelve most outstanding women of past fifty years by the New York World's Fair Committee.

1943

Retrospective exhibition at the Art Institute of Chicago, with monograph by Daniel Catton Rich.

1945

Bought house in Abiquiu, New Mexico.

1946

Retrospective exhibition at the Museum of Modern Art, New York, organized by James Johnson Sweeney. Death of Alfred Stieglitz, July 13.

1947–49

Stayed in New York to work on the Stieglitz estate and prepare two exhibitions of his collections—at the Museum of Modern Art, New York (1947), and the Art Institute of Chicago (1948). Summers spent in New Mexico and began to live in Abiquiu house in fall of 1949. Elected to National Institute of Arts and Letters.

1951–69

Travels: First trip to Mexico, 1951; first trip to Europe (France and Spain), 1953; returned to Spain for three months, 1954; three months along coast of Peru and high Andes country, 1956; traveled around the world for three months, including seven weeks in India, 1959; Japan, Formosa, the Philippines, Hong Kong, Southeast Asia, and some Pacific islands, 1960; Greece, Egypt, and Near East, 1963; England and Austria, 1966; Vienna, 1969.

1960

Retrospective exhibition at the Worcester Art Museum, Worcester, Massachusetts.

1963

Elected to American Academy of Arts and Letters.

1966

Retrospective exhibition at the Amon Carter Museum, Fort Worth, Texas; Museum of Fine Arts, Houston; and University of New Mexico Art Museum, Albuquerque. Elected to American Academy of Arts and Sciences.

1970

Retrospective exhibition at the Whitney Museum of American Art, New York; Art Institute of Chicago; and San Francisco Museum of Art. Awarded the National Institute of Arts and Letters Gold Medal for Painting.

1971–72

Began to lose central vision and retains only peripheral sight. Completes last unassisted oil paintings, but continued to work on paintings with assistance until 1977.

1976–77

Involved in projects, including Viking Press publication *Georgia O'Keeffe* (1976) and Perry Miller Adato video *Georgia O'Keeffe* (1977). Received Medal of Freedom from President Gerald Ford.

1985

Awarded National Medal of Arts by President Ronald Reagan.

1986

Death of Georgia O'Keeffe at age 98, St. Vincent's Hospital, Santa Fe, New Mexico, March 6.

Selected Bibliography

Berry, Michael. *Georgia O'Keeffe: Painter*. American Women of Achievement Series. New York: Chelsea House Publishers, 1988.

Brennan, Marcia. *Painting Gender, Constructing Theory: the Alfred Stieglitz Circle and American Formalist Aesthetics*. Cambridge, Massachusetts: MIT Press, 2001.

Bry, Doris, ed. *Georgia O'Keeffe: Some Memories of Drawings*. Albuquerque: University of New Mexico Press, 1974.

Bry, Doris and Nicholas Callaway, eds. *Georgia O'Keeffe: In the West*. New York: Alfred A. Knopf, 1989.

Bry, Doris and Nicholas Callaway, eds. *Georgia O'Keeffe: The New York Years*. New York: Alfred A. Knopf, 1991.

Callaway, Nicholas, ed. *Georgia O'Keeffe: One Hundred Flowers*. New York: Alfred A. Knopf, 1988.

Castro, Jan Garden. *The Art & Life of Georgia O'Keeffe*. New York: Crown Publishers, 1985; reprint, New York: Crown Trade Paperbacks, 1995.

Cowart, Jack, Juan Hamilton, and Sarah Greenough. *Georgia O'Keeffe: Art and Letters* (exhibition catalogue, National Gallery of Art, Washington, DC). Boston: New York Graphic Society Books, 1987.

Curiger, Bice, Carter Ratcliff, and Peter J. Schneemann. *Georgia O'Keeffe* (exhibition catalogue, Kunsthaus Zurich, Switzerland). Ostfildern-Ruit: Hatje Cantz, 2003.

Drohojowska-Philp, Hunter. *Full Bloom: The Art and Life of Georgia O'Keeffe*. New York: W.W. Norton, 2004.

Eisler, Benita. *O'Keeffe & Stieglitz: An American Romance*. New York: Doubleday, 1991.

Eldredge, Charles C. *Georgia O'Keeffe*. Library of American Art Series. The National Museum of American Art, Smithsonian Institution. New York: Harry N. Abrams, Inc., 1991.

Fine, Ruth E., Barbara Buhler Lynes, with Elizabeth Glassman and Judith Walsh. *O'Keeffe on Paper* (exhibition catalogue, National Gallery of Art, Washington, DC, in association with the Georgia O'Keeffe Museum, Santa Fe). New York: Harry N. Abrams, Inc., 2000.

Hassrick, Peter H., ed. *The Georgia O'Keeffe Museum*. New York: Harry N. Abrams, Inc., 1997.

Hoffman, Katherine. *Georgia O'Keeffe: A Celebration of Music and Dance*. New York: George Braziller, 1997.

Hogrefe, Jeffrey. *O'Keeffe: The Life of an American Legend*. New York: Bantam Books, 1992.

Giboire, Clive, ed. *Lovingly, Georgia: The Complete Correspondence of Georgia O'Keeffe and Anita Pollitzer*. New York: Simon & Schuster, 1990.

Goodrich, Lloyd and Doris Bry. *Georgia O'Keeffe* (exhibition catalogue, Whitney Museum of American Art, New York). New York: Praeger, 1970.

Greenough, Sarah, ed. *Modern Art in America: Alfred Stieglitz and His New York Galleries* (exhibition catalogue). Washington, DC: National Gallery of Art, 2001.

Kornhauser, Elizabeth Mankin, Amy Ellis, with Maura Lyons. *Stieglitz, O'Keeffe & American Modernism* (exhibition catalogue). Hartford, Connecticut: Wadsworth Atheneum, 1999.

Lisle, Laurie. *Portrait of an Artist: A Biography of Georgia O'Keeffe*. New York: Seaview Books, 1980; reprinted, New York: Washington Square Press, 1987.

Loengard, John. *Georgia O'Keeffe at Ghost Ranch: A Photo Essay*. New York: The Neues Publishing Company, 1998.

Lynes, Barbara Buhler. *Georgia O'Keeffe: Catalogue Raisonné* (two volumes.) New Haven: Yale University Press; National

Gallery of Art, Washington, DC; Georgia O'Keeffe Foundation, Abiquiu, New Mexico, 1999.

Messinger, Lisa Mintz. *Georgia O'Keeffe*. New York: Thames and Hudson, 2001.

Newman, Sasha. *Georgia O'Keeffe*. Washington, DC: The Phillips Collection, 1985.

O'Keeffe, Georgia. Introduction to *Georgia O'Keeffe: A Portrait by Alfred Stieglitz* (exhibition catalogue). New York: The Metropolitan Museum of Art, 1978.

O'Keeffe, Georgia. *Georgia O'Keeffe*. New York: Viking Press, 1976; reprinted, New York: Penguin Books, 1985.

Peters, Sarah Whitaker. *Becoming O'Keeffe: The Early Years*. New York: Abbeville Press, 1991; Revised, New York: Abbeville Press, 2001.

Pollitzer, Anita. *A Woman on Paper: Georgia O'Keeffe*. New York: Simon & Schuster, 1988.

Robinson, Roxana. *Georgia O'Keeffe: A Life*. New York: Harper & Row Publishers, 1989; reprinted, Hanover: University Press of New England, 1999.

Turner, Elizabeth Hutton. *Georgia O'Keeffe: The Poetry of Things*. (exhibition catalogue, The Phillips Collection Washington, DC). New Haven: Yale University Press, 1999.

Wagner, Anne Middleton. *Three Artists /Three Women: Modernism and The Art of Hesse, Krasner and O'Keeffe*. Berkeley: University of California Press, 1996.

Videotape

Adato, Perry Miller, producer and director. *Georgia O'Keeffe*. Videotape, color, 60 minutes; WNET/THIRTEEN for Women In Art, 1977. Distributed by Home Vision Entertainment.

Photograph Credits

© The Art Institute of Chicago
(cat. 10, 35, 70)

Ben Blackwell
(cat. 11)

© Brauer Museum of Art
(cat. 47)

Blair Clark (cat. 75)

Kent Clawson, Des Moines
(cat. 22)

Geoffrey Clements (cat. 21)

© CNAC/MNAM Dist. RMN -
© Philippe Migeat
(cat. 25)

Paul Macapia (cat. 17)

© 1988 The Metropolitan
Museum of Art (cat. 36)

© 2006. Digital image,
The Museum of Modern Art,
New York/Scala, Florence
(pp. 15, 16 upper left, 16 upper
right, 18, 19 left; cat. 33, 77)

Don Myer (cat. 53)

Image © 2006 Board of
Trustees, National Gallery
of Art, Washington
(cat. 44, 45, 72, 74)

© The Newark Museum/Art
Resource/Scala, Florence
(cat. 28)

Nienhuis/Wall (cat. 51)

© Georgia O'Keeffe Museum,
Santa Fe/Art Resource/Scala,
Florence
(pp. 23, 29; cat. 4, 19, 31, 34,
55, 62, 65, 71, 73)

© 2006. Photo The Philadelphia
Museum of Art / Art
Resource/Scala, Florence
(cat. 6)

Larry Sanders (cat. 66, 67)

© 2006. Photo Scala, Florence
(cat. 5)

Stephen Sloman
(p. 17 left; cat. 20, 29, 59, 69)

© 2006 Smithsonian American
Art Museum / Art Resource /
Scala, Florence
(p. 16 bottom left)

© The Solomon R. Guggenheim
Foundation, New York. David
Heald (p. 17 right)

Lee Stalsworth (cat. 46)

© Museo Thyssen-Bornemisza,
Madrid (cat. 9, 61)

Malcolm Varon © 1997 The
Metropolitan Museum of Art
(cat. 14)

Malcolm Varon © 1984 The
Metropolitan Museum of Art
(cat. 18, 54)

Malcolm Varon © 1987
The Metropolitan Museum
of Art (cat. 30)

Malcolm Varon, NYC. (cat. 27)

James M. Via (cat. 2)

Copyright Todd Webb,
courtesy of Evans Gallery and
Todd Webb Trust, Portland,
Maine, USA (pp. 12, 20, 24, 27,
28)

Bruce M. White © Trustees
of Princeton University
(cat. 49)